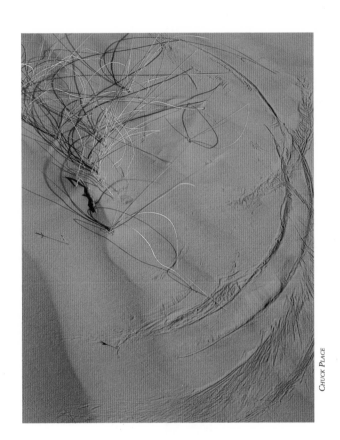

CHUCK PLACE

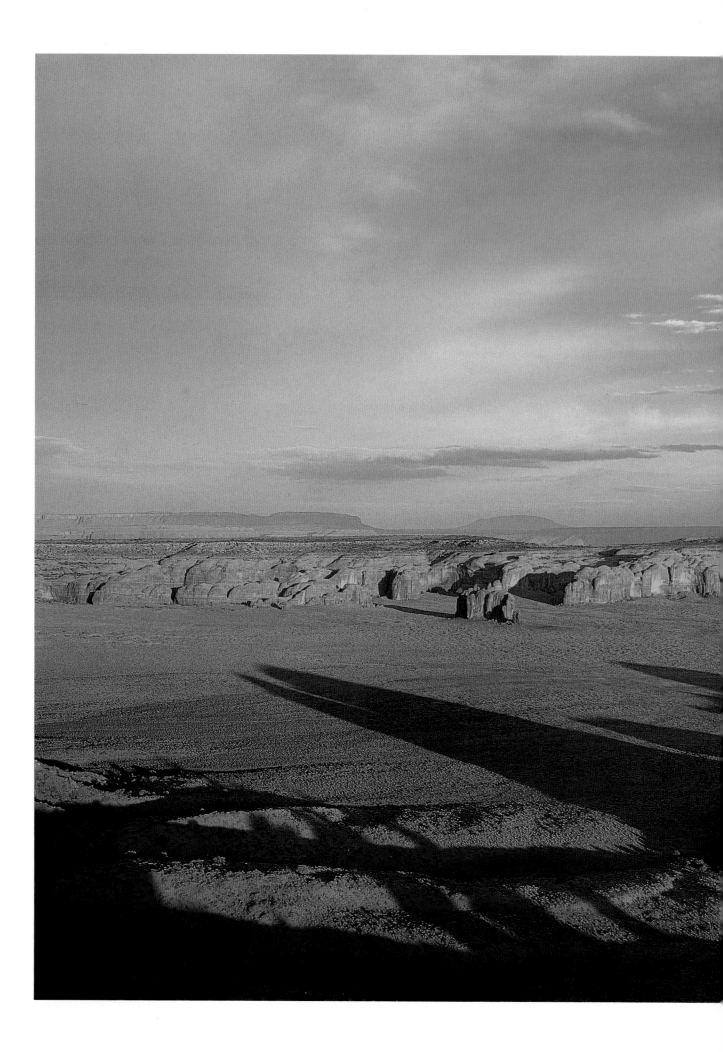

MONUMENT VALLEY

NAVAJO TRIBAL PARK

Text by Anne Markward

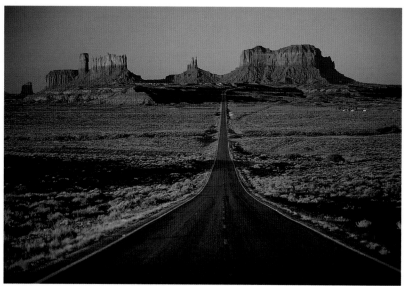

CARA MOORE

Jane Freeburg, Publisher/Editor
Edited by Mark A. Schlenz
Designed by Linda Trujillo

With special thanks to Bernice Platero Casaus, Navajo Instructor,
Fort Lewis College, for her assistance with the Navajo translations
and text review; to Dr. Grant Frankenburg, Instructor/Education
Faculty, Fort Lewis College; and to Gerald and Roland LaFont.

ISBN 0-944197-20-5 *(softcover)*

ISBN 0-944197-22-1 *(clothbound)*

ISBN 0-944197-21-3 *(multi-language edition)*
French translation by Stephen M. Bunson
German translation by Erika Berroth
Japanese translation by Words That Work

9 8 7 6 5 4 3 2

CONTENTS

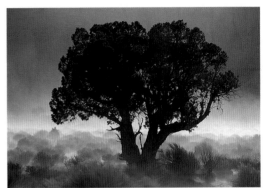

FRED HIRSCHMANN

CHUCK PLACE

CARA MOORE

CONTRIBUTING PHOTOGRAPHERS

Ray Atkeson, Frank Balthis, Jeff Brouws,
Dennis Flaherty, Jeff Gnass, Carol Havens,
Fred Hirschmann, Kerrick James, Harry Jarvis,
Gary Ladd, JC Leacock, Craig Lindsay, Maggie MacLaren,
Cara Moore, Jeff Nicholas, Chuck Place, Guy Rolland,
Dale Schicketanz, Tom Till, Tulley & Ballenger,
Larry Ulrich, Richard Weston, and Robert Winslow.

CHUCK PLACE

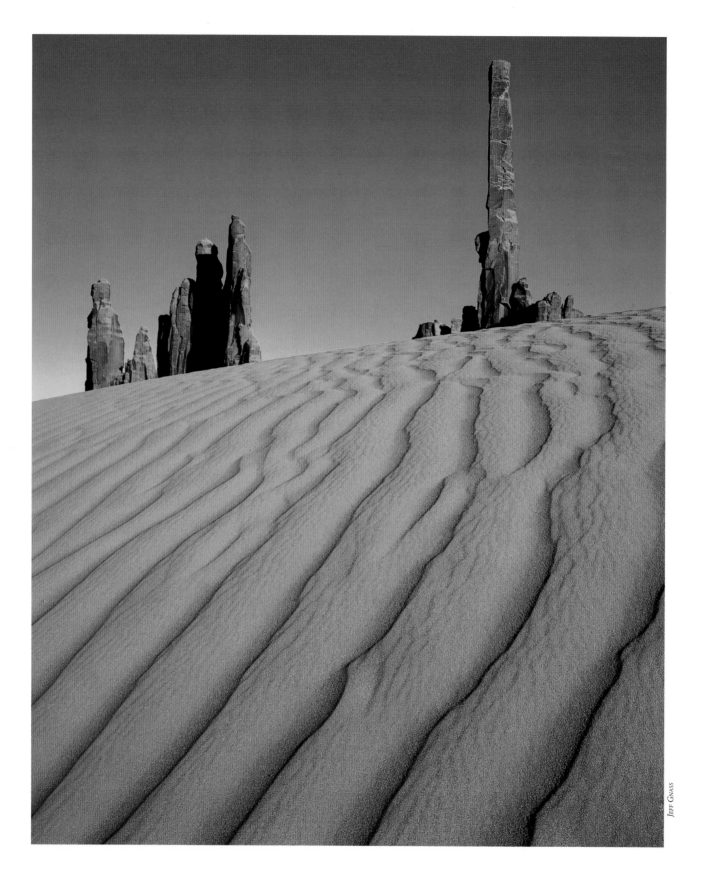

*Wind creates intricate patterns in the sand
before the Yei Bi Chei and Totem Pole formations.*

RHYTHMS OF THE LAND

CARA MOORE

The beginning of the world,
I am thinking about it;
The beginning of the world,
I am talking about it.

First, there was the world of Darkness. But the People were not happy there and, with the aid of their gods, moved gradually up through three more worlds before emerging into the world of the present. From blackness, they travelled through worlds shimmering with blue, then yellow, then white. The Holy People created four mountains as cornerstones to a sacred homeland in the Present World, one in each of the four cardinal directions, each covered with one of four different beautiful stones. East, south, west and north; white shell, turquoise, abalone and jet. There shine the colors of dawn, early twilight, evening sunset and night. The Earth people now have an even more simple name for themselves: the Diné. The People. Other cultures know them as Navajo.

"Religion" as a word does not exist in the Navajo language; daily life and spiritual beliefs are too closely enmeshed for any distinction to be made. It is said that the more prayers and songs a Navajo knows, the more he is likely to be in harmony with the world around him. Songs greet the dawn, encourage rain, pray for good harvest and hunts. One ceremony, the "Blessing Way"—which roughly translates into English as "for good hope"—lays the foundation for many Navajo

beliefs. The Holy People first taught it to the Diné when they created mankind to help the People pray for health, prosperity, and general well-being. The prayers and songs of the Diné—as when musicians interpret a score while preserving the music's integrity—influence nature's outcome but do not try to control it.

Nature has its own rhythm, its own sweet timing. Cycles borne of millenia still continue, and the Diné have lived traditionally within these cycles. Mother Earth, fecund and receiving, gathers up the blessings sent by Father Sky—warming sunlight and soaking rains. Cycles of fertility, blessings of nature, continuity of life. Man is but one thread in the weaving, rather than master of the design. Each animal, bird, pebble and plant has its own power, and is honored with a spiritual and ceremonial importance. Animals serve as mentors, imparting the strengths of patience, wisdom, endurance, quickness, cunning. Birds, wings fanned out against the sky like wind, or like a bank of towering, moisture-bearing clouds, merit special awe, respect—and sometimes fear. As Navajo storyteller Rosa Benally explains to Terry Tempest Williams in *Pieces of White Shell*, "The wild beasts, birds, are my friends—messengers. Protectors. Their sacred names, their ancient songs, are the keys to their world—a world of no time, a world of harmony. If everyone would look to their beast and fowl brother, one could learn the mysteries of Mother Earth."

To speak of community for the Diné is to refer to all the communities of life. Just as people are part of the earth's community, the individual is part of a family, and of a clan. Strict cultural codes and values,

germinated from centuries of isolated living in a harsh land, ensure certain individual privacies within the greater context: survival of the tribe. Precious commodities of the land belong to everyone; wood for fuel and building, salt deposits for the animals' wellbeing and, of course, water—the most cherished commodity of all. No one clan may control these gifts to the People. Within families, though, each sheep or horse is owned by one member of the family; even very young children have their own animals. The owner's wishes are usually obeyed in regard to that animal or possession, but the individual is expected to choose what is best for the whole. The highest ideal of behaviour? To act toward all people as if they were one's own relatives. The emphasis lies again in *influencing*, not controlling.

Navajo language is subtle, the sounds unlike any most world travelers have ever heard. The accent on one syllable, or the elongation of a vowel, may change a statement's meaning entirely. Minute variations of sound and apparent homonyms provide rich ground for shades of meaning and subtle, cunning puns—a constant delight for appreciative listeners. As with other orally-based cultures, the Diné tell stories rich with the lessons learned over many generations. Stories of emergence, stories of the hunt, legends concerning the formation of earth and sky, moon and constellations. Legends that provide a framework of philosophy, balance and good sense. Stories told between autumn's last thunder and its first drumroll in spring, while the animals are sleeping deeply. Stories that offer a strategy for living in this relentless landscape, and for surviving countless more generations.

In the desert, all things fit so well, so precisely. They fit—or they quickly die. Plants, animals and even people have acclimated to searing sun, crystal cold nights, devil winds, and precious little water. To many travelers, the desert looks completely parched, devoid of any life-giving liquid. But, as Edward Abbey wrote in *Desert Solitaire:*

> There is no shortage of water in the desert but exactly the right amount, a perfect ratio of water to rock, or water to sand, insuring

that wide, free, open, generous spacing among plants and animals, homes and towns and cities, which makes the arid West so different from any other part of the nation. There is no lack of water here, unless you try to establish a city where no city should be.

Everything in the desert adjusts to the arid, often brutal, conditions—plants flower briefly in spring, using the fleeting extra moisture to bloom, seed, and then retrench for another blazing summer. Many have leaves that fold together, allowing less surface for moisture to escape, or barbed spines and bitter points to deter browsing animals.

Most desert creatures are nocturnal; mice and pack rats, cottontails and coyote all dart about under the cooler cover of darkness. Bats' wings may brush the air overhead and, far off, coyotes may yip and yowl triumphantly over their evening kill. The desert, somnolent by day, rhythmically hums and vibrates at night.

The desert people, the Diné, are also masters at adaptation. Their homes, called hogans, fit into this terrain well. Thick mud walls insulate against both summer's heat and winter's chill, maintaining a comfortable interior temperature while quietly sinking into the surrounding red rock colors. Hogans are not out of place, but rather an almost natural extension of the landscape.

We think of Monument Valley as eternal. Certainly, from man's limited viewpoint, it so appears. But the eternal is not static; the Valley is changing— albeit by mere millimeters—with every season. Dynamic forces of the earth, wind and water built and sculpted the dramatic forms of this land. The visible rock of Monument Valley, carved today into buttes, monoliths and mesas, represents millions of years of contrasting landscapes: a sea-level assortment of low-lying hills, riverbanks and estuaries overlaid by massive sand dunes blown in from the ancestral Rockies and then once more coursed over by streams. Time compressed these soft sediments into layers of rock,

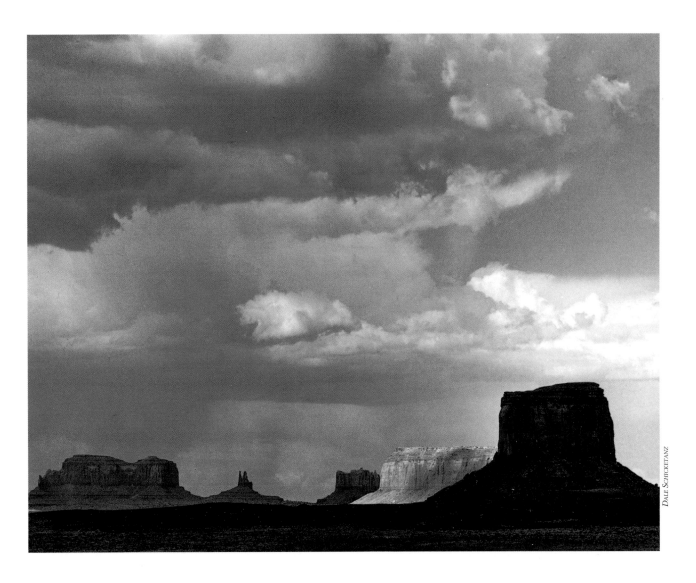

some thousands of feet deep, with strata of different colors delineating entirely different epochs. This region, and all the vastness around it, is part of the 130,000 square mile Colorado Plateau, a pyramidal-shaped uplift whose northern point lies in the Uinta Mountains of northern Utah and whose southern base runs from northeastern Arizona to west-central New Mexico. Sixty-five million years ago this plateau began to rise gently to a uniform elevation, sloping five thousand to thirteen thousand feet above the original sea level, with most horizontal strata still intact. But even as the plateau gradually lifted, erosion began cutting it back down once more, wearing away at its surfaces and along its faults and breaks. Wind and rain slowly ate at softer surfaces, leaving pockets and markers of harder rock still standing. Level lands eventually became trenched with deep canyons sliced into rock by relentless streams. In places, especially toward the southern end of the plateau, canyons widened so much that only harder-surfaced rock—

shaped into towers, monuments, buttes and mesas—survived, littered remnants of the disappearing uplift.

And still the cliff walls retreat. Look along a burnished flank of rock; see the cracks and sudden, lighter colored, inset blocks of missing stone. Or notice the small collections of talus—broken up rock rubble—at the base of each monument. Considering the tremendous forces of erosion constantly attacking the monuments, little debris accumulates at their feet. The high, dry desert air disintegrates chunks of rock into sand and dust fragments almost immediately, and the infrequent rains running down cliff faces wash away most traces of weathering.

Ian Thompson, in *Four Corners Country*, describes this landscape as "a place of rearing, plunging, freezing, scorching rock, not an easy place for life to find a foothold or toehold." But plantlife did root, and eventually supported a small animal community, which in turn fed a larger set of predators, which one day, thousands of years ago, convinced man that this

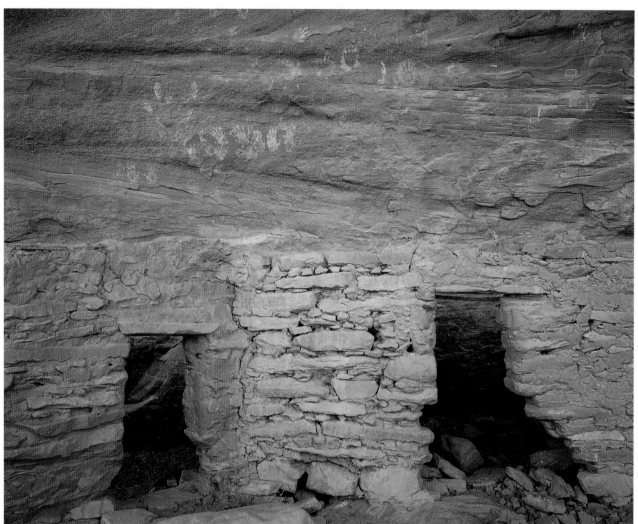

TOM TILL

(Above) The Anasazi, who lived in this region until A.D. 1300, decorated the rock alcove behind House of Many Hands with their handprints; they pecked the horned quadruped into stone near Echo Cave.
(Opposite) Navajo in traditional dress demonstrate sandpainting skills.

was land worth traveling in his constant, nomadic way. The quest for wild game led man back and forth across these vast distances, following each season's warmth or water from low canyon bottoms to high mountain meadows. Man had been a hunter/gatherer, existing off the land rather than manipulating it through agriculture, for almost two million years.

Why did man first choose to settle and farm, rather than wander and harvest nature's feast? Why did early peoples first choose these rock valleys, more full of sand and thorns than water and sweet grasses?

A people settled into the recessed rock alcoves dotting this region at least one thousand years ago, lived here peacefully for centuries, then wandered on, following the promise of better water. The dwellings we see sheltered in cliff niches today once belonged to a people the Navajo named *Anasazi*, the Ancient People: those who were here for many generations, who first filled these caverns with laughter and song, whose children first spied tadpoles in spring's earliest waters.

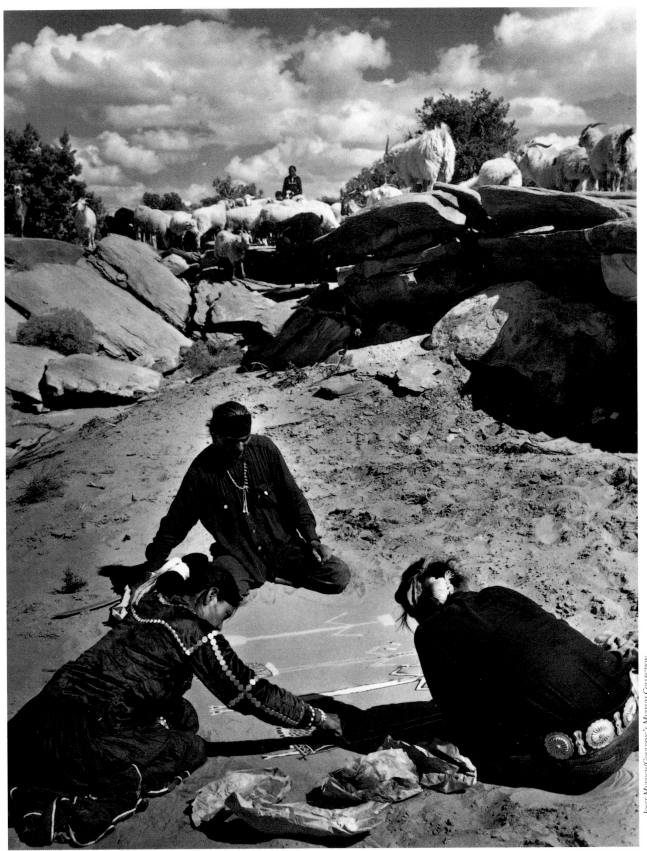

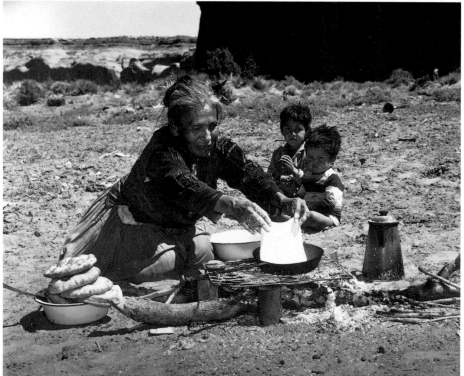

We have shards of their decorated pottery, shreds of old sandals, and abandoned granaries to explore. We have petroglyphs chiseled into the rock—speaking of big horn sheep, deer, and good water holes, the seasons' cycles and the earth's fertility. These legends in stone tell us they were here, but not the story why—about A.D. 1300—the Ancient People left their homes.

Perhaps two hundred years passed before the Diné came to Monument Valley in the late fifteenth or early sixteenth century. These Native Americans share language roots tracing back to the Athapaskans of the far, far north. Some traditional Navajo ceremonies invoke the spirits of buffalo and other Plains Indian deities, lending credence to the probability that the People wandered from the north through what is now the mid-west before reaching the Four Corners region. Here the Navajo encountered descendents of the Anasazi: the peaceful, agrarian Hopi, Zuni and Pueblo tribes of the Southwest.

The Navajo assimilated quickly. They adopted agriculture and more or less permanent homes, and they abandoned many of their nomadic patterns. They wove strains of the Puebloan religions into their ceremonies and so strengthened their own healing chants.

When the Spanish introduced the sheep and horse to Native Americans in the early 1600s, the Navajo claimed these as their own and began intensive herd cultivation as well as wool and mutton produc-

(Above) A Navajo woman makes fry bread for her family the traditional way, over an open fire.
(Below) Sheep graze on the sparse vegetation of Monument Valley. Navajo herders raise sheep for wool and mutton.

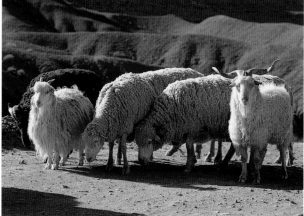

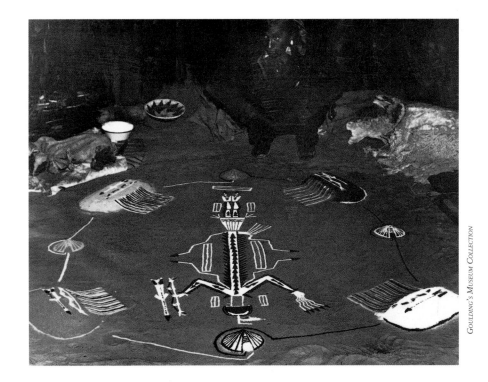

Sandpaintings are an important part of Navajo healing ceremonies. To restore balance and harmony, the sandpainting, or iikááh, is created with great care on the earthen hogan floor— which represents Mother Earth—in accordance with sacred beliefs. The sandpainting is later swept into a blanket, carried outside, and disposed of— along with the illness or misfortune addressed by the ceremony.

GOULDING'S MUSEUM COLLECTION

tion. The horse gave back freedom of movement to the Diné, and allowed them more contact with other cultures.

By the mid-1800s, Euro-Americans had defeated the Spanish and staked the West for their country's rapid expansion. An intensive land grab began. Settlers moving into the area encroached on ancestral native lands, and the Army was called in to back up the takeover. Kit Carson led the round up of Navajo and Apache peoples and, in 1864, herded eight thousand of them, by foot, several hundred miles from their homes. "The Long Walk" to Bosque Redondo, near Fort Sumner in eastern New Mexico, will long be remembered among the Diné with sadness and some animosity. Attempts to reestablish the Navajo failed miserably—two years of pests wiped out all crops and a severe drought strangled the land. Thousands died from pneumonia, tuberculosis, and dysentery. In 1868, a treaty was signed at last to guarantee peace and allow the Navajo to return to their homelands—much reduced during their forced absence. With promises given of government support to buy more sheep and seed, the Navajo began to rebuild their lives.

A small band of Navajo, led by Chief Hoskininni, had escaped the initial round up and eked out a living in the arroyos and ravines of Monument Valley. These survivors helped their returning clansfolk start again. Few white people came into the area to bother them; those that did—like two silver-crazed miners—were warned away. Most listened. The miners did not, and

were killed beneath the buttes which today bear their names—Merrick and Mitchell. Others, like the infamous Butch Cassidy gang, often rode through but respected the Diné's privacy.

Traders settled near Monument Valley, in Kayenta and Oljato, but not until a young man named Harry Goulding heard that land was open for settlement did any Anglos try to come here permanently. Harry Goulding had a reverent eye for the Valley's grand landscape. A tall, lanky, soft-spoken man, Harry originally hailed from a booming little town named Durango in southwest Colorado. There, he had met and married a local girl named Leone, whom he nicknamed "Mike" because, after all, that was easier to spell. When land opened up in 1921 in Monument Valley, he quickly collected a herd of sheep, stuffed all his belongings into a one-and-a-half- ton truck and a soft-topped Buick, and headed west. He bought six hundred and forty acres of land that year for fifty cents an acre—and felt it was the best $320 he'd ever spent.

The Gouldings spent the first four years on their land living and trading out of tents near one invaluable spring. Eventually they enlisted the aid of two visiting trappers and built, in the same area, a trading post with a small apartment on top. Finished in 1928, Goulding's old stone trading post cozies up to the seven hundred-foot cliff of Big Rock Door Mesa with a heartstopping view out over the buttes and rock columns of Monument Valley. The building still stands, now as a museum filled with photographs and memorabilia.

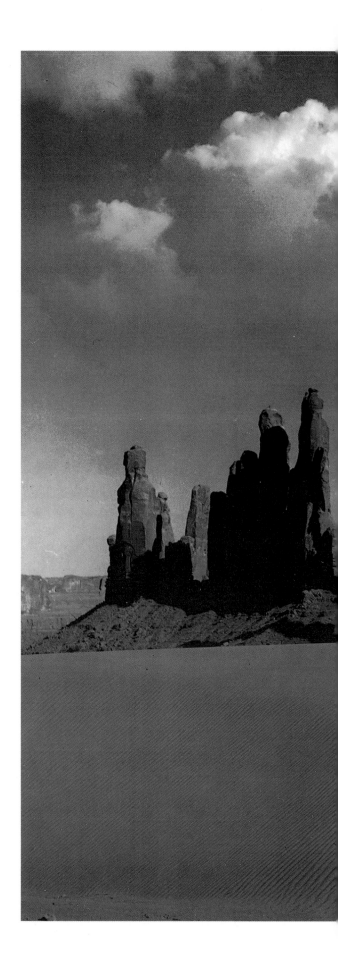

Hózhǫ́ǫgo shighan dooleeł;
 shikee' dóó shitsijį'
 hózhǫ́ǫ dooleeł.
 Shiyaahgi, shideigi, shinaagóó
 hózhǫ́ǫ dooleeł.

Hózhǫ́ǫgo shikǫ' hólǫ́ǫ dooleeł
 sha'ał chíní bá, hózhǫ́ǫ doo.
 T'áá ałtsojį' hózhǫ́ǫ dooleeł.

Hózhǫ́ǫgo nihich'įįyą' hólǫ́ǫ dooleeł;
 yódí át'éí hózhǫ́ǫ doo.
 Índa k'ee'ąą kwááníłł dooleeł.

May it be delightful, my house;
 from my head to my feet,
 may it be delightful.
 Where I lie, all above me,
 all around me,
 may it be delightful.

May it be delightful, my fire,
 may it be delightful for my children.
 May all be well.

May it be delightful with my food and theirs;
 may all my possessions be well,
 and may they be made to increase.

 —NAVAJO PRAYER

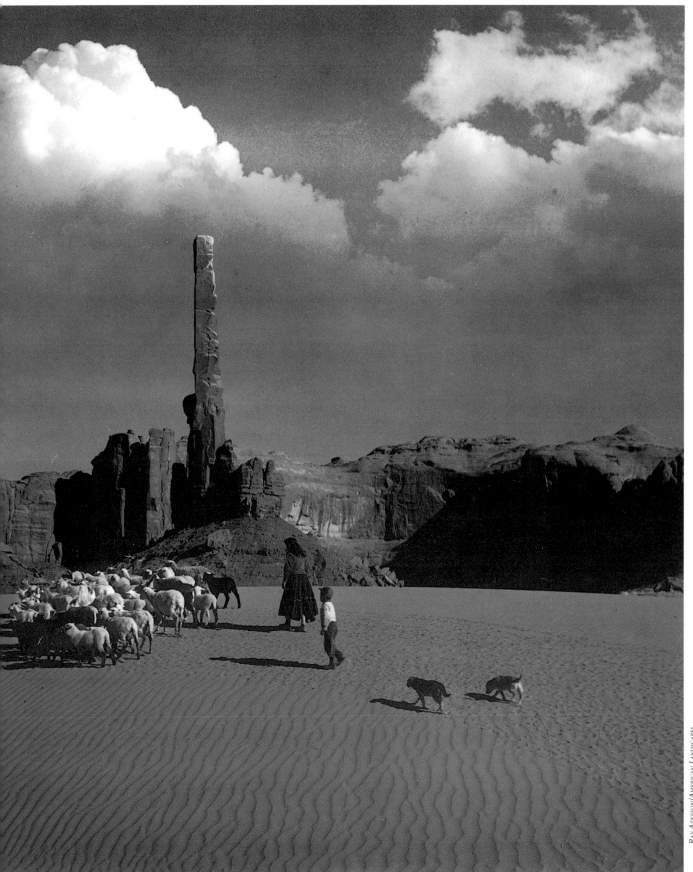

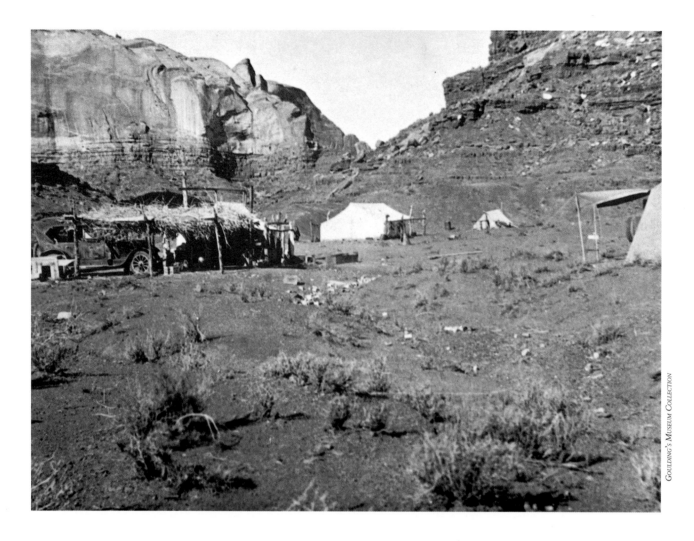

The Depression years hit the Navajo Nation even harder than the rest of the United States. The People had expanded their sheep flocks so successfully that the land was viciously overgrazed. A government-forced sale of thousands of sheep at below-market prices left the Navajo with little economic hope. There were no jobs, and with the reduction in livestock for sale, no cash.

One of the only industries booming anywhere in the country was that of movie-making. Harry and Mike heard of one director's search for the perfect backdrop for a new Western. With a stack of photographs of the Valley, the Gouldings drove to Hollywood. Persistence, patience and a healthy dose of luck finally led Harry to film director John Ford. The stunning shots of Monument Valley convinced Ford to start immediately.

Within a week, the first crew of one hundred stagehands—preceded by eleven supply trucks—arrived in Monument Valley to begin shooting the Academy Award-winning film of 1938, *Stagecoach*. Both the director and lead actor, a young man named John Wayne, were delighted with the spectacular

setting. Both John Ford and John Wayne returned again and again to make more movies.

The Gouldings were ecstatic. Two of their most important goals—to provide income for the Navajo tribe (some $48,000 for work as extras and crew for *Stagecoach* alone) and to publicize the beauty of Monument Valley—had been met.

John Ford's films created the backdrop for an entire generation of moviegoers' views of "the West." Ford's visual images imparted a sense of wonder for the West's grandeur; the rusty, rugged beauty of Monument Valley has become synonymous with wild open spaces. Ironically, historic events treated in storylines of later films rarely occurred against the breathtaking background scenery of the region. *Cheyenne Autumn* (1964) depicts the Cheyenne people's desperate return from relocation in Oklahoma across the plains to their ancestral home near present day Yellowstone National Park—yet the movie features Monument Valley's red rock desert terrain. In other films, Navajo horsemen play the parts of fierce Comanche or Apache. But, just as the craggy monuments and buttes have been reposi-

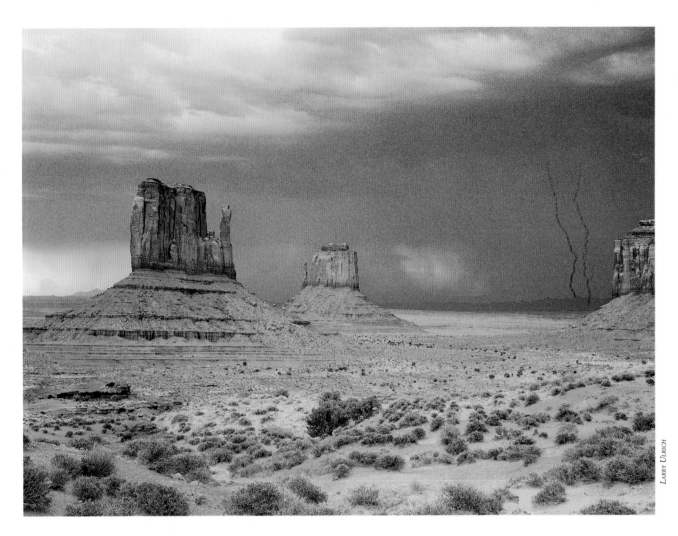

LARRY ULRICH

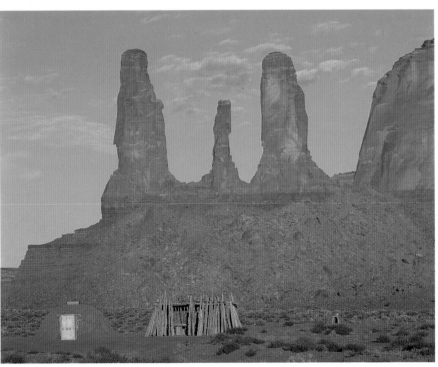

TOM TILL

(Opposite) Harry and Mike Goulding's original tent camp at the base of Big Rock Door Mesa. (Above) Stormy skies over Monument Valley. (Left) Traditional Navajo hogans and a summer shade house, built by hand in harmony with their surroundings.

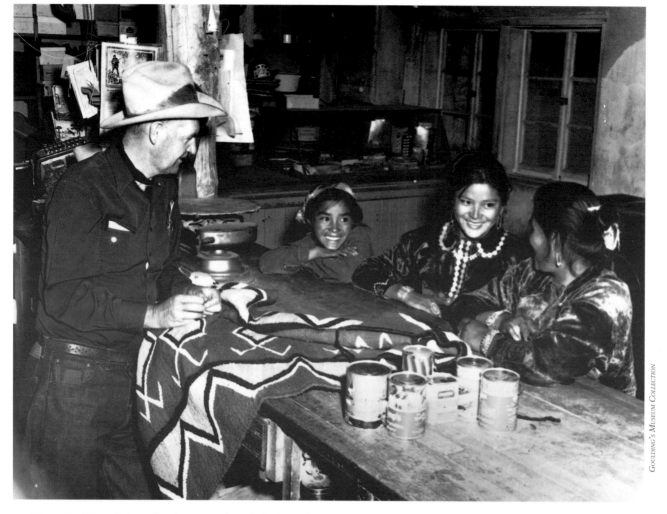

Harry Goulding admires a handwoven rug brought in for trade.

tioned to suit cinematography, so much of American movie lore about the struggles between cowboys and Indians has been fabricated with little basis in cultural, moral or geographic reality. Hollywood exuberantly creates its own legends.

For the Navajo, reality was far different. Although not permitted U.S. citizenship until 1924, Navajo served with distinction in each world war. During World War II, the famed "Codetalkers" used their subtle native language to transmit military information between American forces, totally baffling all translation attempts by the Japanese. Casualties among the People both then and in subsequent wars waged by the United States have been severe, often decimating a clan's menfolk.

Today the Navajo Nation is the largest—both in land and population—Native American tribe in the United States. The Reservation and its outlying checkerboard areas occupy 32,000 square miles in three of the "Four Corners" states—Arizona, New Mexico, and Utah. The Navajo Nation has tenaciously pursued self-determination. The 1950 Navajo–Hopi Rehabilitation Act encouraged all possible enterprises— irrigation projects, industrial development, roads, communications, health and education programs—to be undertaken by Navajos. The Navajo Tribal Council, the Reservation's legal governing body, developed a Tribal Code and court system which integrates modern western thought with traditional Navajo values. Today, all visitors to the Navajo Nation are subject to these laws and Tribal courts.

As early as the 1930s the National Park Service recommended that Monument Valley be protected from development. But National Parks typically do not allow permanent residents within their boundaries. The Navajo Tribal Council established the 29,816-acre Monument Valley Tribal Park in 1958—ensuring that this spectacular land would be preserved for its physical beauty as well as for its ancestral and contemporary importance to the Diné.

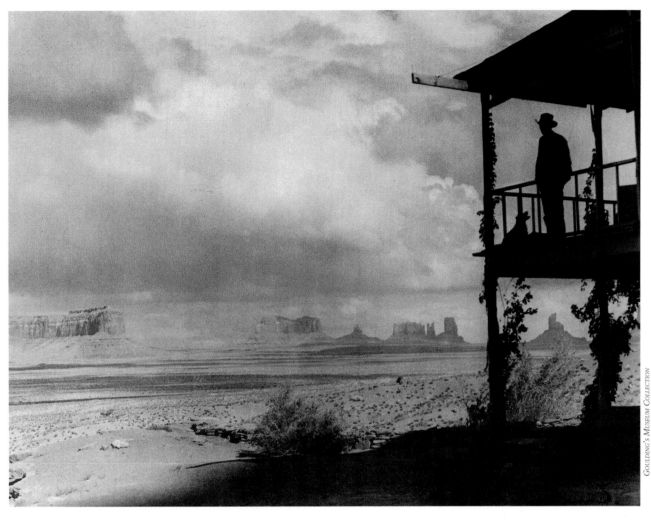

Harry and his dog Brownie take in the view from the Trading Post.

Today, Monument Valley Tribal Park offers its residents a more traditional lifestyle than experienced elsewhere on the Reservation, but it also exemplifies some of the changes that have come to the People. Modern buildings—a visitor center and giftshop—now perch on the Valley's rim. Navajo residents drive home over dusty roads in their 4x4 pickups. Many younger people wear casual western clothing, while their grandparents still don velvets. And, while some still tend flocks of sheep on the Valley's floor, many now host the flocks of tourists instead.

Tourism has brought mixed blessings to Monument Valley. Most Navajo earn their living from visitors—either selling jewelry and crafts or working directly in the hospitality industry. Many feel that it is good that people from all over come to admire their land; most hope that guests will leave, not only with a different view of the rocks and history of this desert place, but also with some sense of Monument Valley's special harmony.

Remember: Monument Valley Tribal Park is not "the middle of nowhere." While at first it may appear barren and empty to you, it is full of glorious life and mythic memory. Every mineral-varnished rock wall and hidden water cistern, every twisted tree and bristling yucca is known by the Diné; each is part of the Diné's home, as much as the looms or cooking pots within a hogan. Treat the land and all things on it with the respect tradition counsels. Believe that each pebble, bird, plant, person, rock, mouse, flower, insect, lizard and cottontail has its own power—its own inscrutable reason for being in this place—and should be honored. Let the rhythm of this land thrum through your soul; let the voice of its spirit call you home.

> Homeward now shall I journey;
> Homeward upon the rainbow;
> Homeward now shall I journey,
> Lo, yonder the Holy Place.

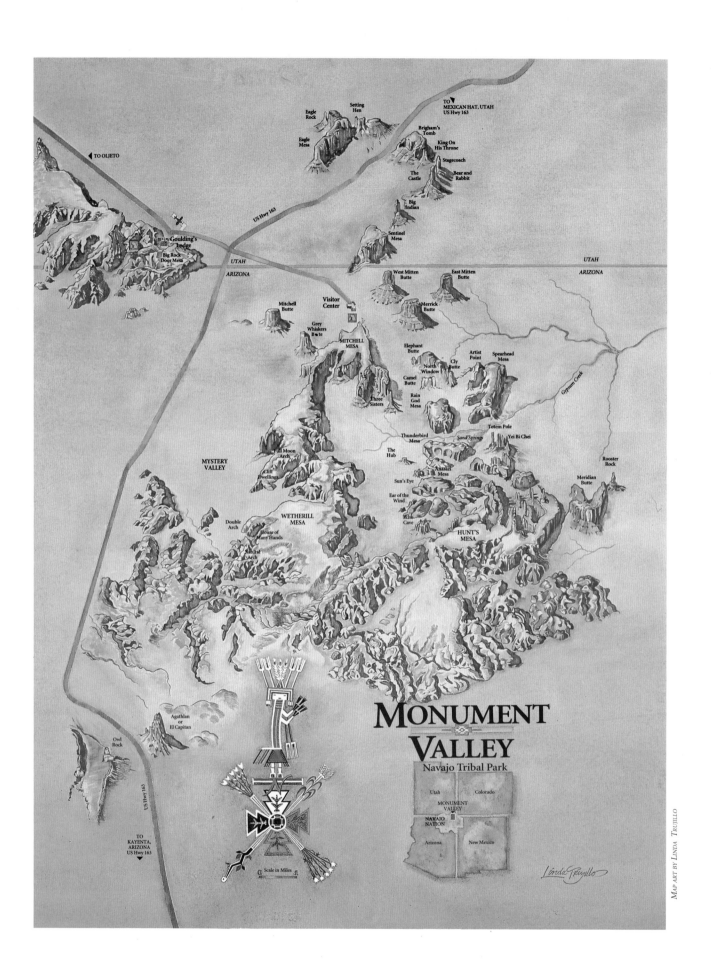

MONUMENT
VALLEY
Navajo Tribal Park

MAP ART BY LINDA TRUJILLO

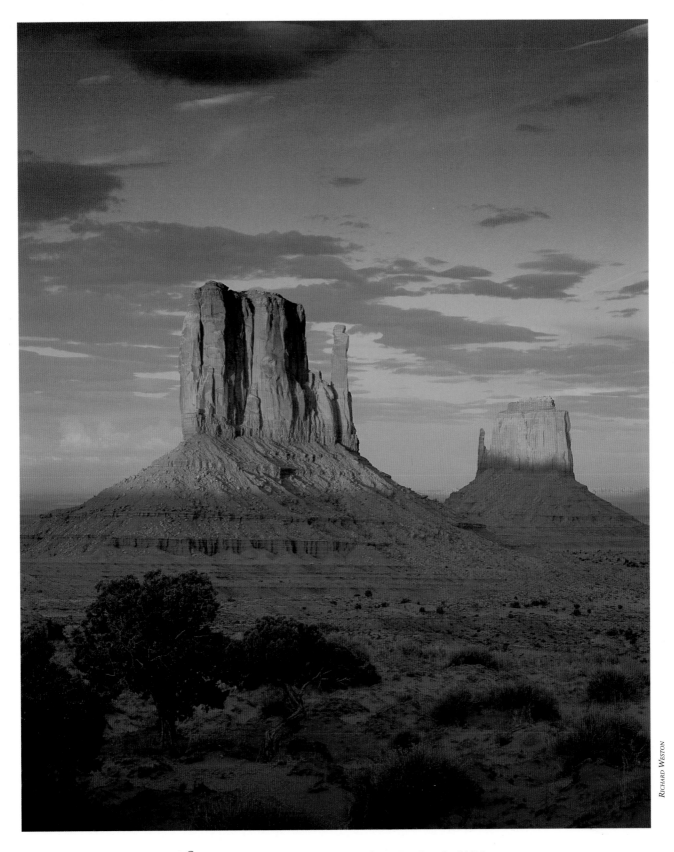

Sunset bathes the West and East Mitten formations in red-gold light.

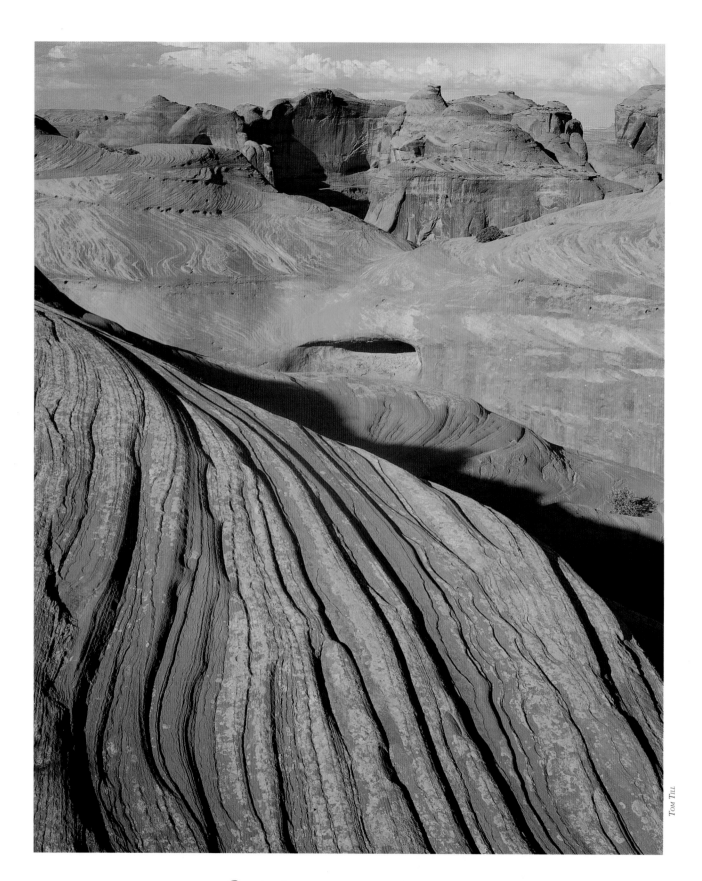

*Centuries of wind and water have eroded this sandstone
into the swirled slickrock, domed rock forms, and mysterious
alcoves of Hunt's Mesa.*

Tom Till

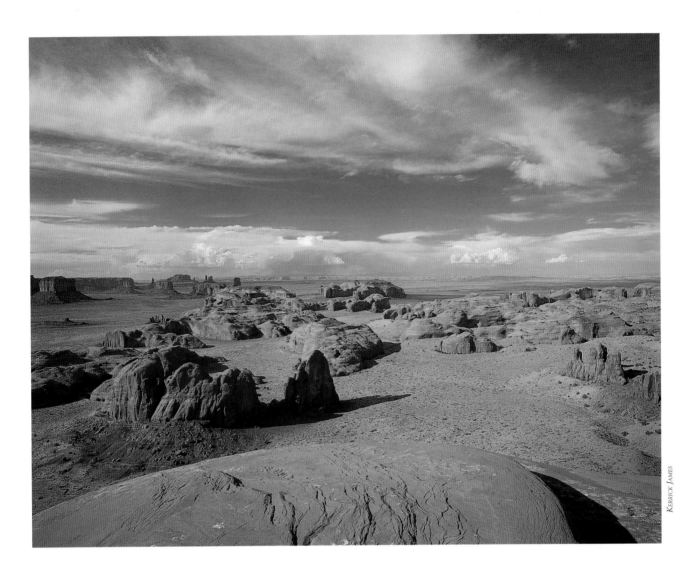

Monument Valley: red to blue, great violet shadows, planes and prisms of light.

The valley is vast. When you look out over it, it does not occur to you that there is an end to it. You see the monoliths that stand away in space, and you imagine that you have come upon eternity. . . .

The most brilliant colors on earth are there, I believe, and the most beautiful and extraordinary land forms—and surely the coldest, clearest air, which is run through with pure light.

–N. Scott Momaday,
The Names, *1976*

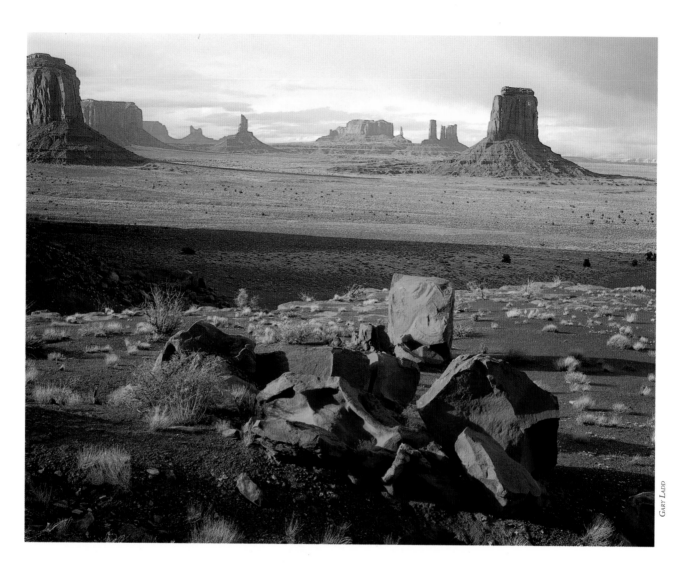

*Viewed from the North Window in mid-March, the
great monoliths of Monument Valley cast late afternoon shadows.*

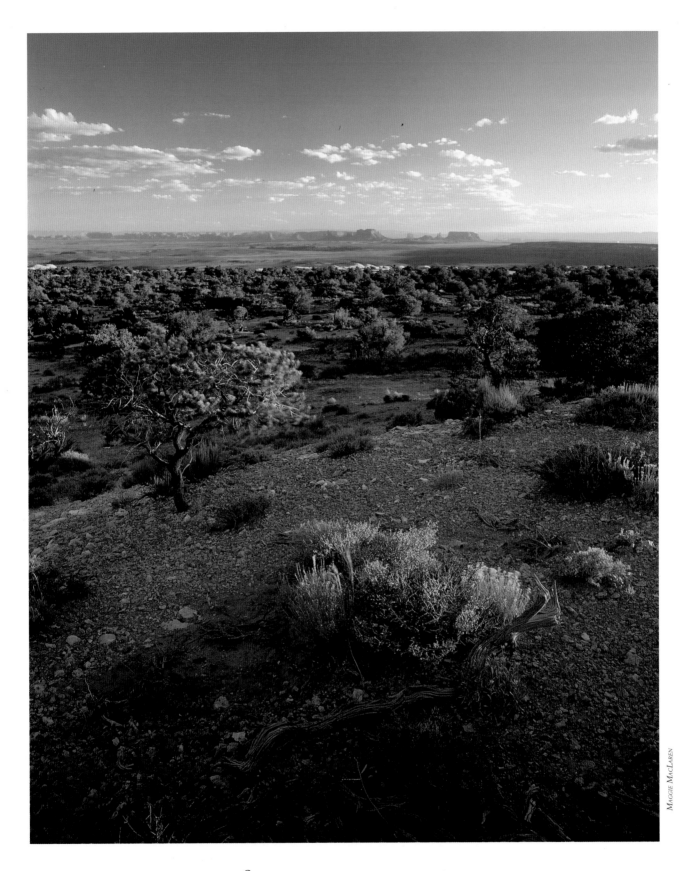

MAGGIE MACLAREN

*Seen from atop Cedar Mesa in southern Utah,
the distant sandstone shapes of Monument Valley
appear to rise from the desert floor.*

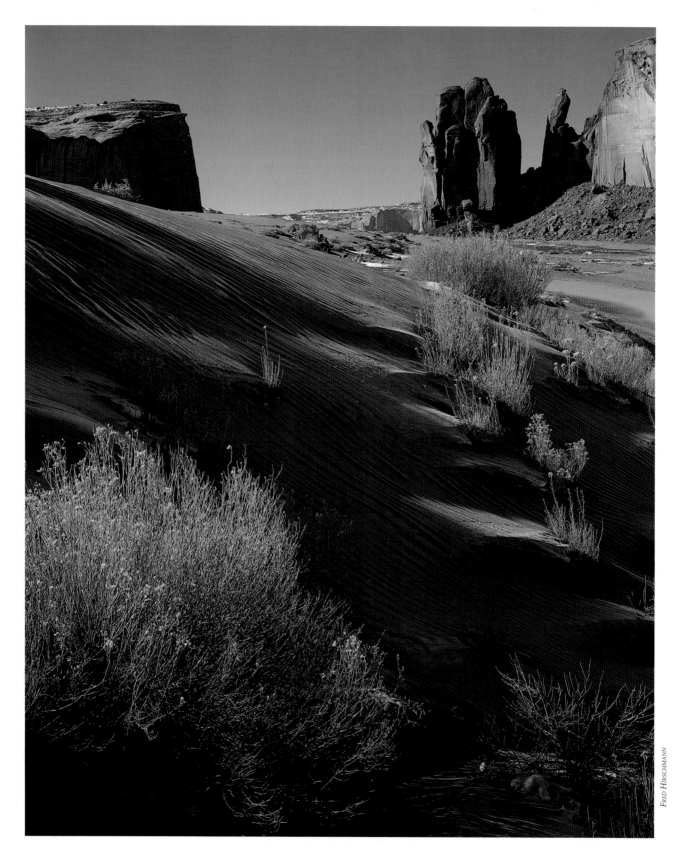

*Frost sparkles in wind-driven sand
dunes before Rain God and Spearpoint Mesas.*

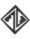

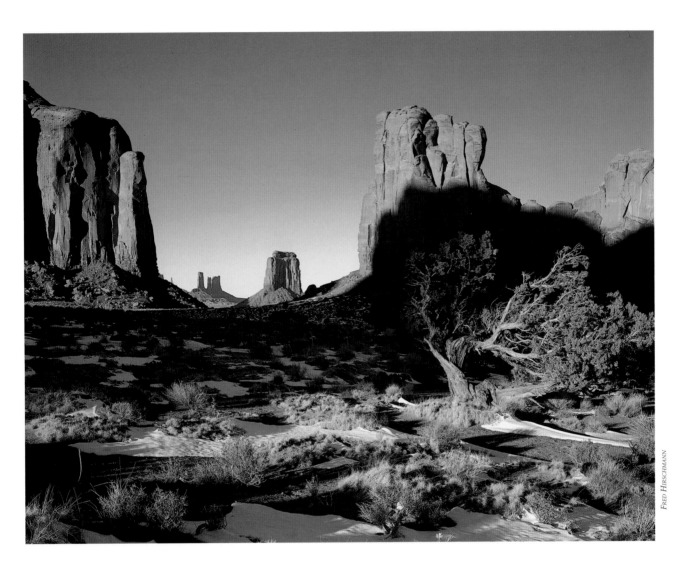

*Gnarled limbs of a hardy juniper catch the
winter afternoon light near the North Window.*

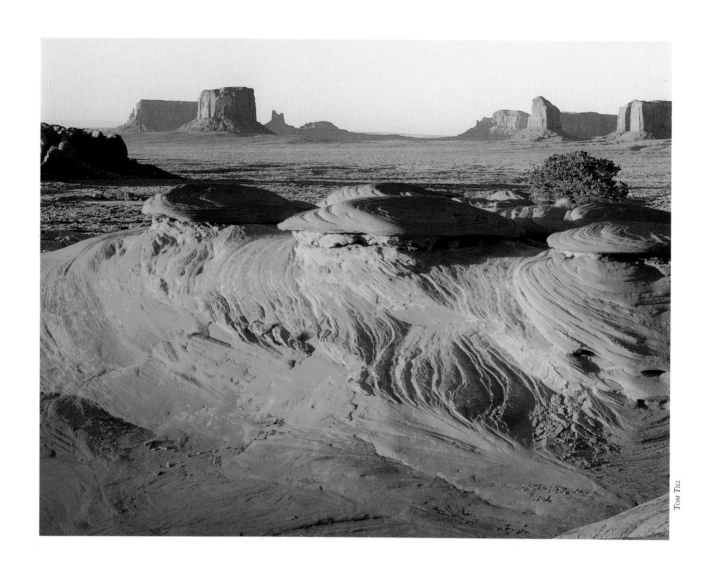

TOM TILL

. . . the colors are such as no pigments can portray. They are deep, rich and variegated, and so luminous are they, that light seems to glow or shine out of the rock rather than to be reflected from it.

—CLARENCE DUTTON,
GEOLOGY OF THE HIGH PLATEAUS OF UTAH, *1880*

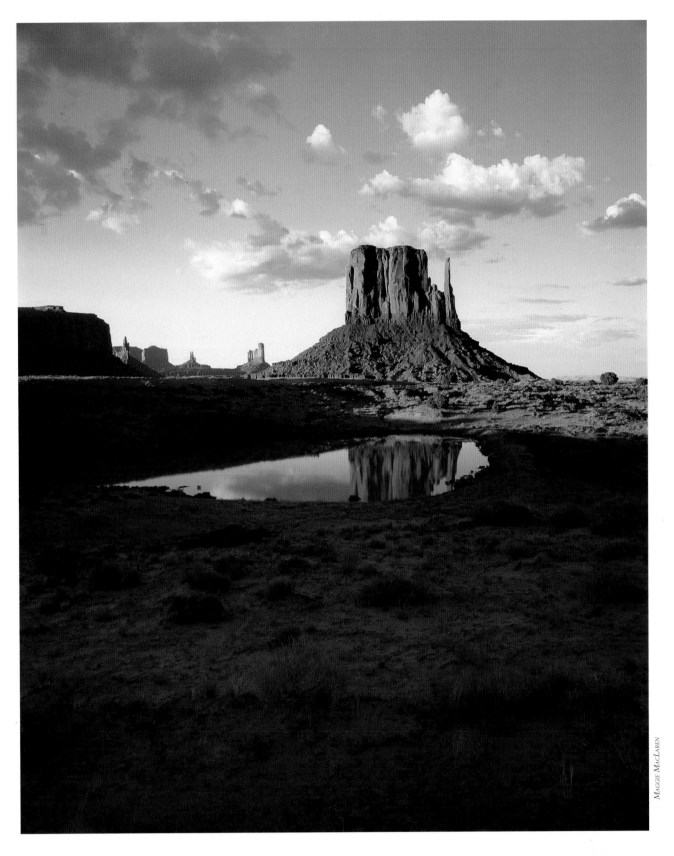

Still rain water reflects the rocky face of West Mitten Butte.

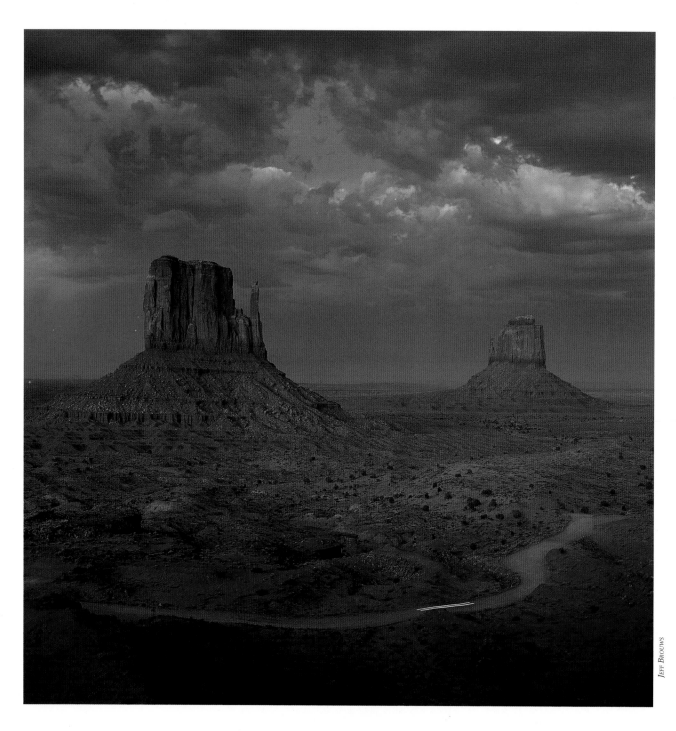

JEFF BROUWS

A *seventeen-mile unpaved road winds through*
Monument Valley, offering ever-changing views of
the majestic landforms.

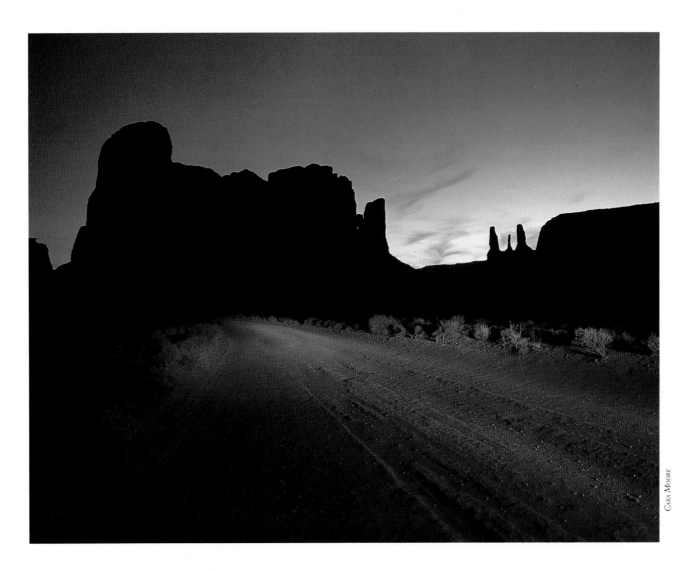

*W*ith the coming of evening, dark shapes loom over the park road.

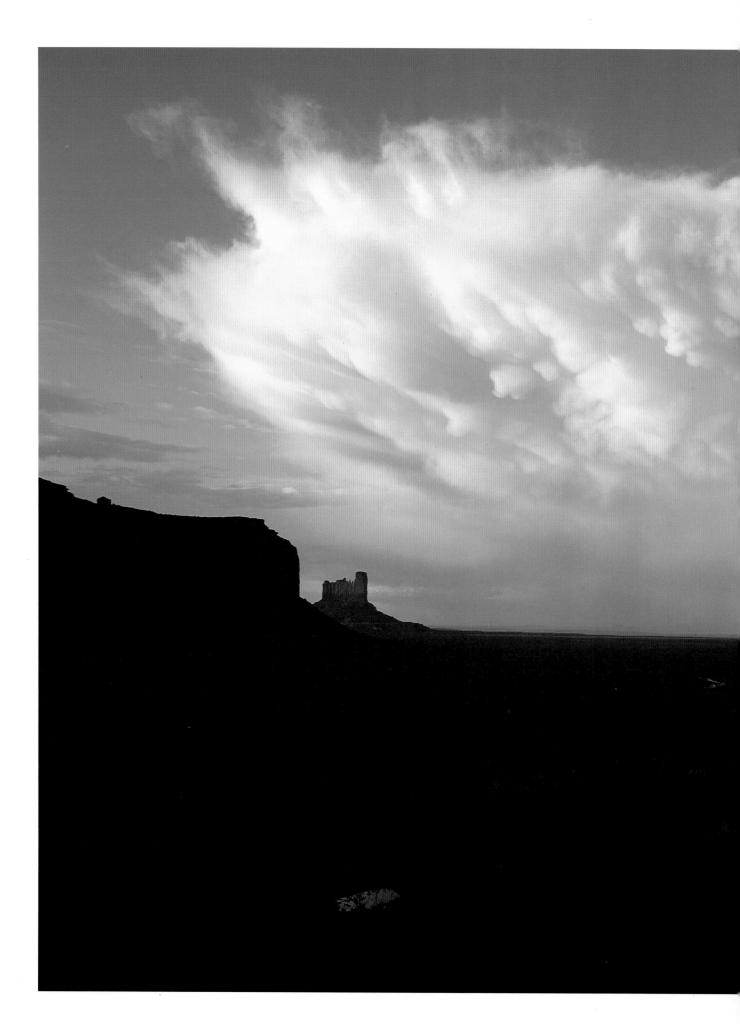

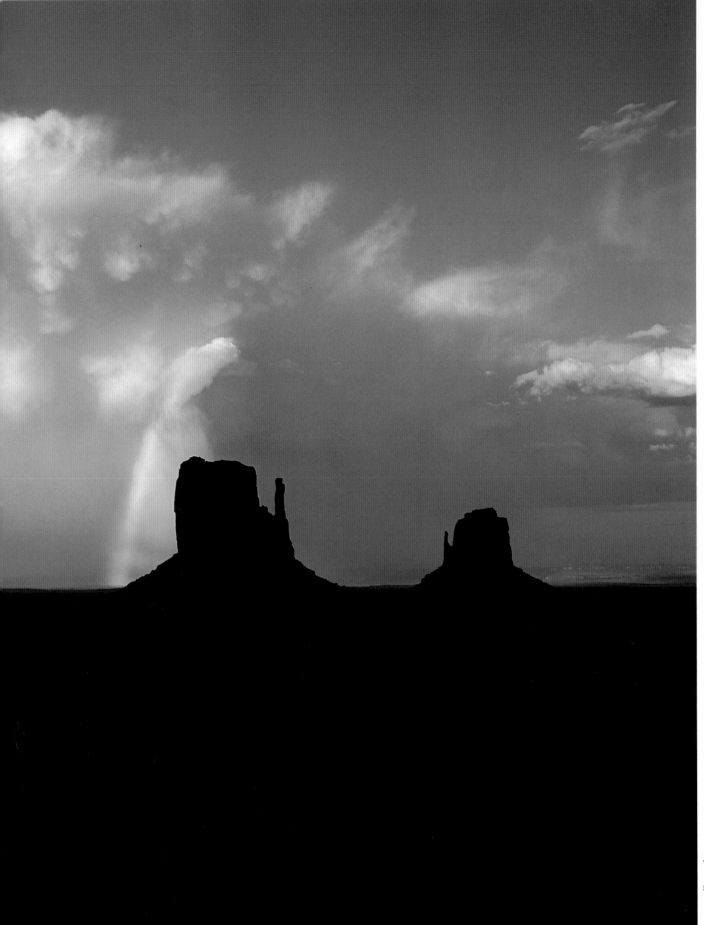

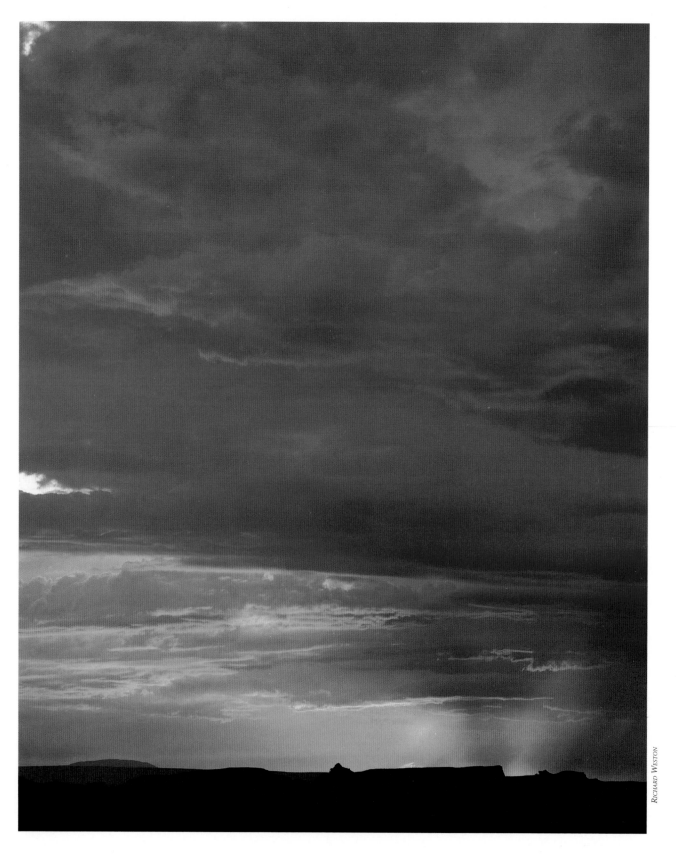

Sunset over Oljeto Mesa, from Monument Valley.

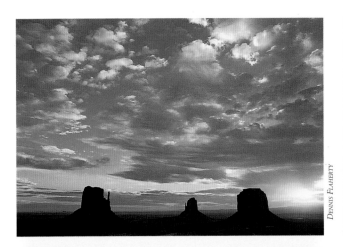

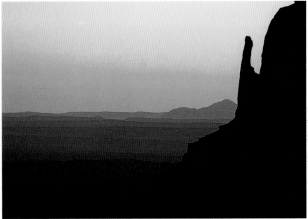

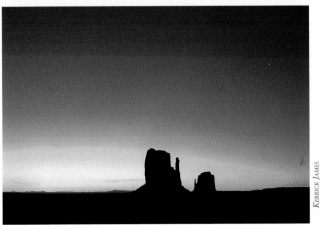

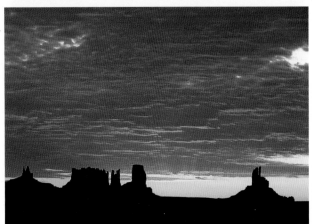

Hoos'įid bi'éé' haslį́į'
Jį́ ashkii bi'éé' haslį́į'
Nahasdzáán bi'éé' haslį́į'
T'áá bíláąjį', Hayíłką́ hadiidzaah.

Daybreak is clothed
Daylight Boy is clothed
Mother Earth is clothed
Before them, Dawn adorned herself.

—NAVAJO POEM

35

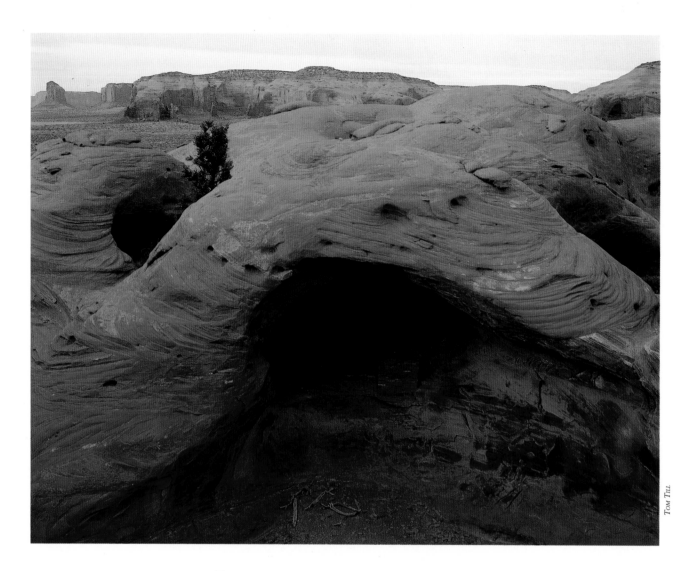

Tucked within a protective sandstone alcove, Square House
Ruin is a silent reminder of the Anasazi ("Ancient People" in Navajo)
who flourished in the Southwest until A.D. 1300.

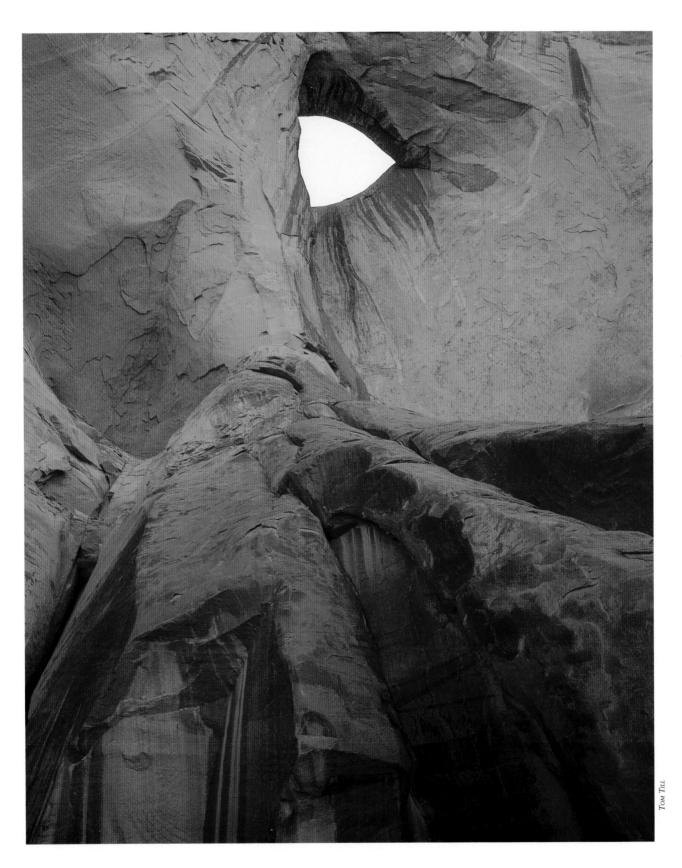

TOM TILL

*Desert varnish streaks the rock
below a window called "The Sun's Eye."*

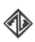

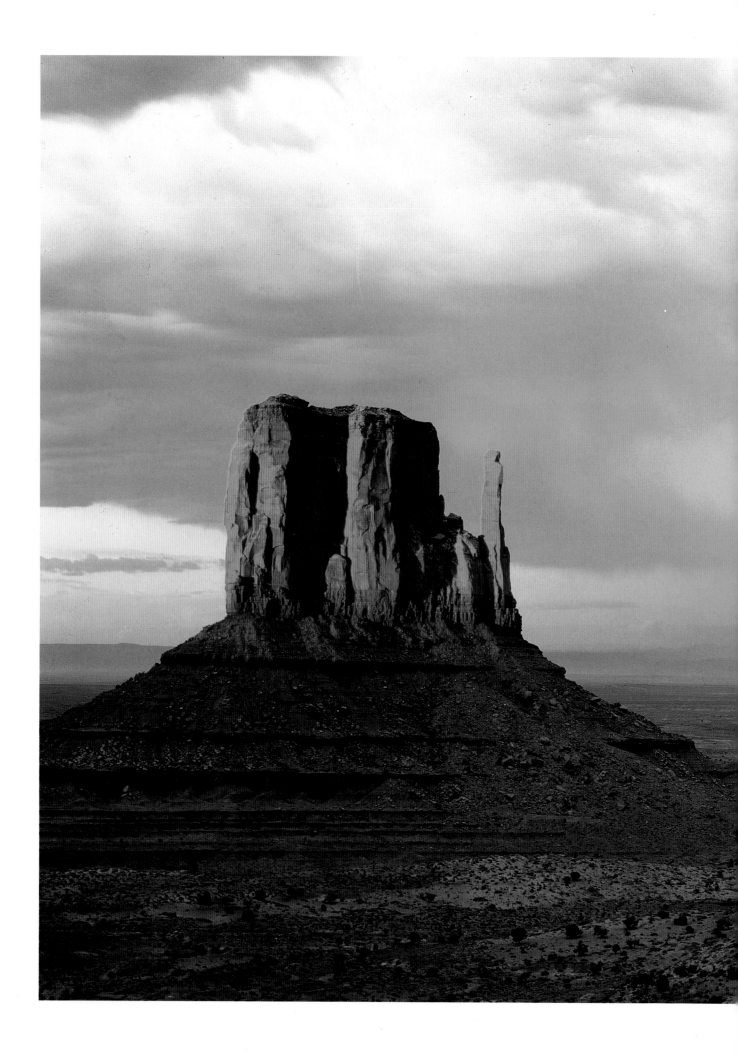

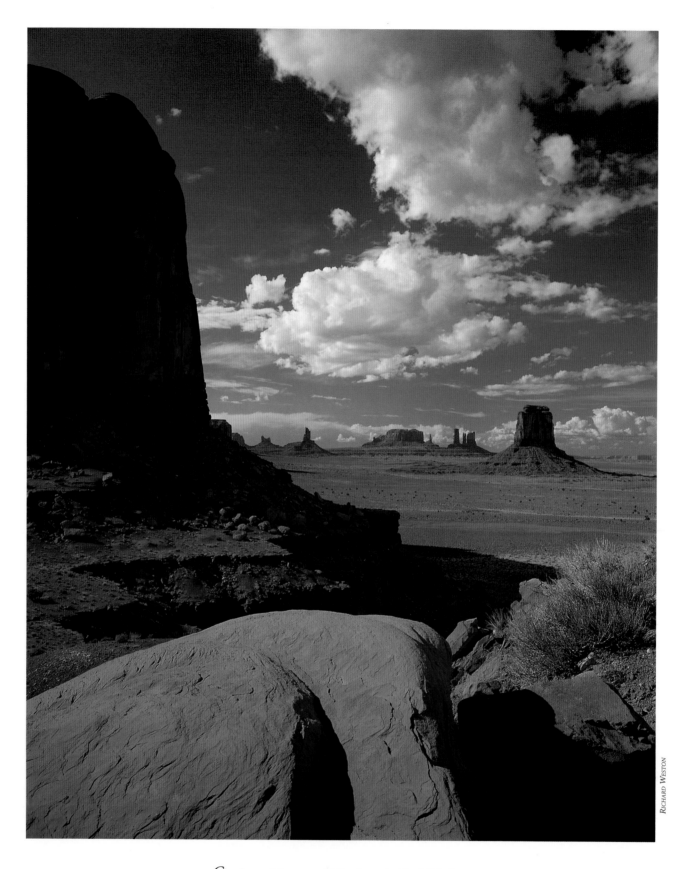

Clouds over Monument Valley, from the North Window.

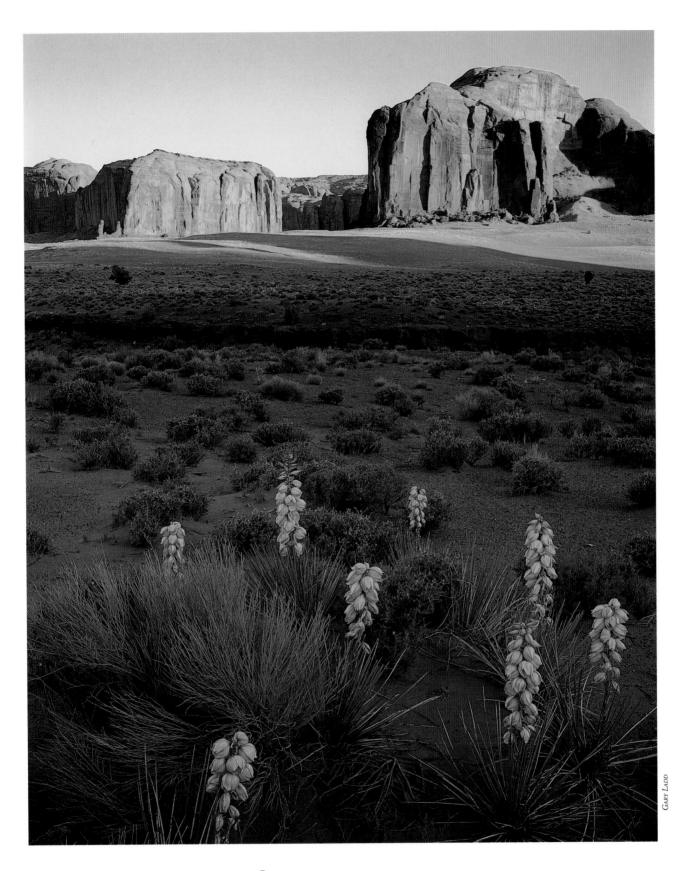

Gary Ladd

*Creamy-white blooms of the yucca plant
burst from the desert floor in late May.*

41

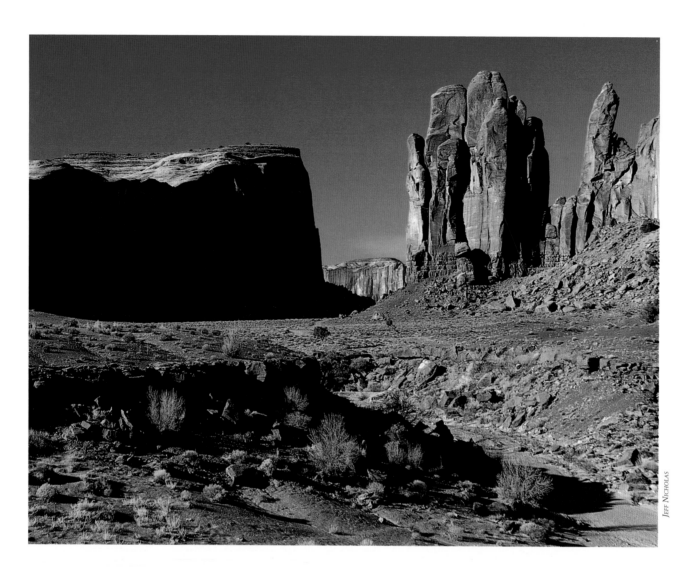

JEFF NICHOLAS

Shí, Nahasdzáán biniłch'i' diyinii nishłį́
Nahasdzáán bikee', shí shikee'
Nahasdzáán bijáád, shí shijáád
Nahasdzáán biinéí', shí shinéí'
Nahasdzáán bintsékees, shí shintsékees.

Shí, ałtsé diyinii nishłį́
Hózhǫ́ǫgo shik'ehgo iiná.

I, I am the spirit within the earth
The feet of the earth are my feet
The legs of the earth are my legs
The voice of the earth is my voice
The thoughts of the earth are my thoughts.

I, I am the most high power
Whose ways are beautiful.

—*Prayer from the Blessing Way*

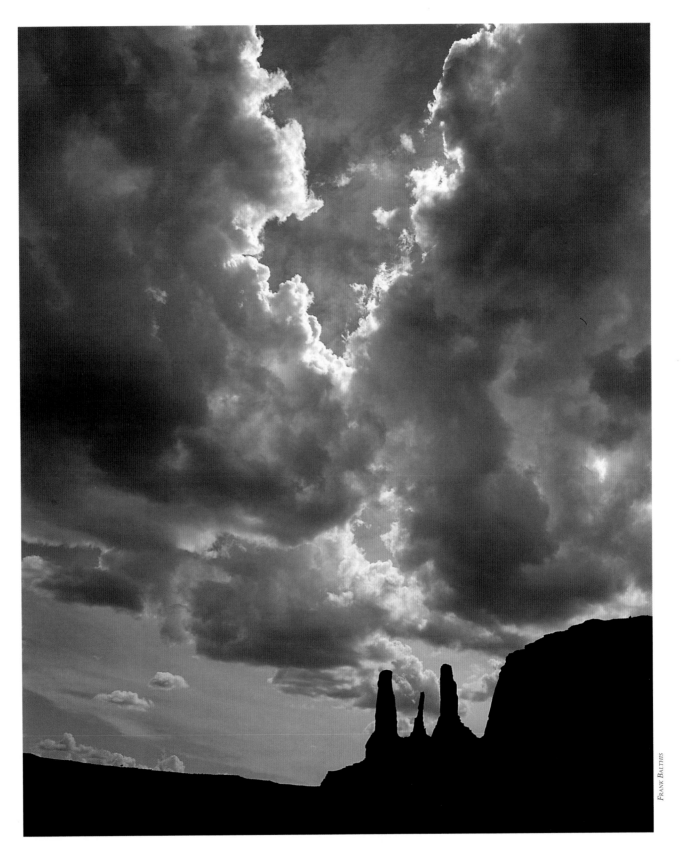

*The Three Sisters silhouetted
against running clouds.*

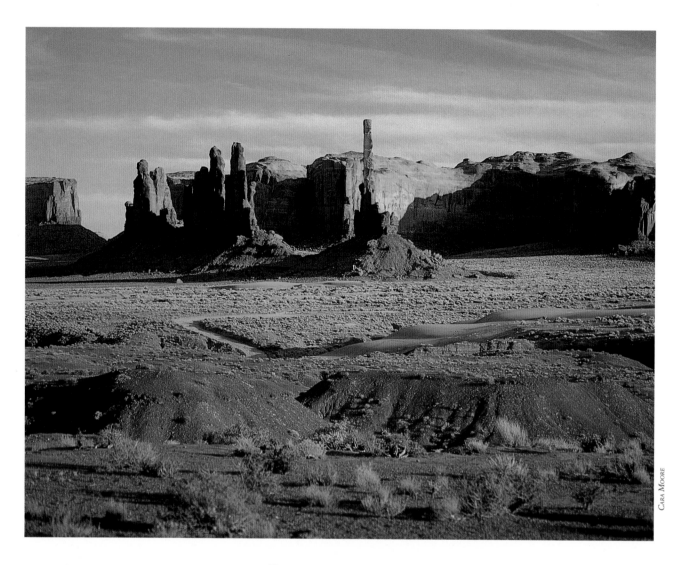

Desert plants adapt to the harsh
landscape of eroded red rock and sculpted sand dunes.

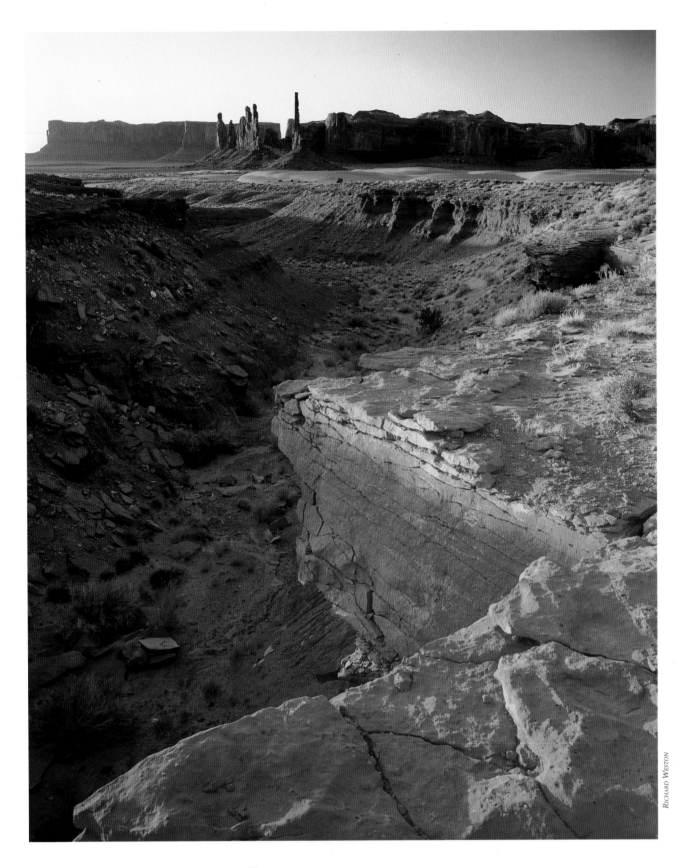

*First light brushes the side of a rocky arroyo
leading to the Yei Bi Chei and Totem Pole formations.*

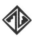

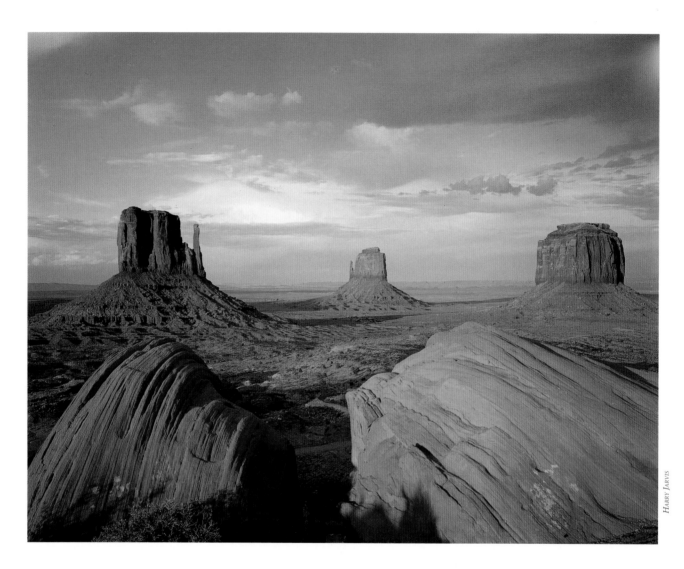

*Sunset glows on the red sandstone of the
West and East Mitten and Merrick Butte.*

Shik'éí keehat'įįdi
áadi tádíshááh.
Kinłichí'ídi
áadi tádíshááh.
Iiná nineezii bee hooghan
bii' tádíshááh
Hózhóonii bee hooghan
bii' tádishááh.
Sạ'ạh naagáí, bik'eh hózhóón
bik'ehgo tádishááh
Atiin hozhǫ́ǫniigóó
yishaał

Where my kindred dwell,
There I wander.
The Red Rock House,
There I wander.
In the house of long life,
There I wander.
In the house of happiness,
There I wander.
In old age traveling,
There I wander.
On the beautiful trail I am,
With it I wander.

—NAVAJO SONG

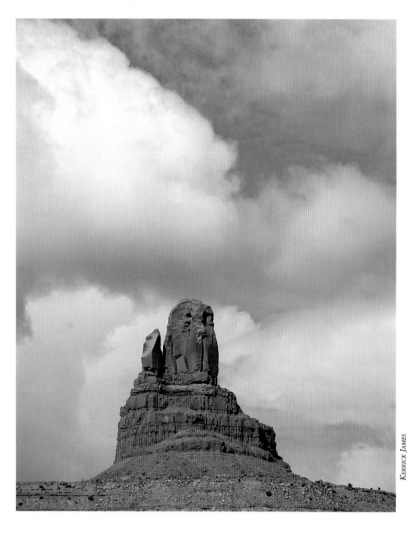

KERRICK JAMES

The rhythm of the rocks beats very slowly, that is all. The minute hand of its clock moves by the millions of years. But it moves.

—COLIN FLETCHER,
THE MAN WHO
WALKED THROUGH
TIME, *1968*

Owl Rock, above, evokes the visage of its namesake bird. Twin arches in this sandstone formation in Mystery Valley, right, bear the nickname "The Spectacles." Below right, The Thumb stands silhouetted against Rain God Mesa.

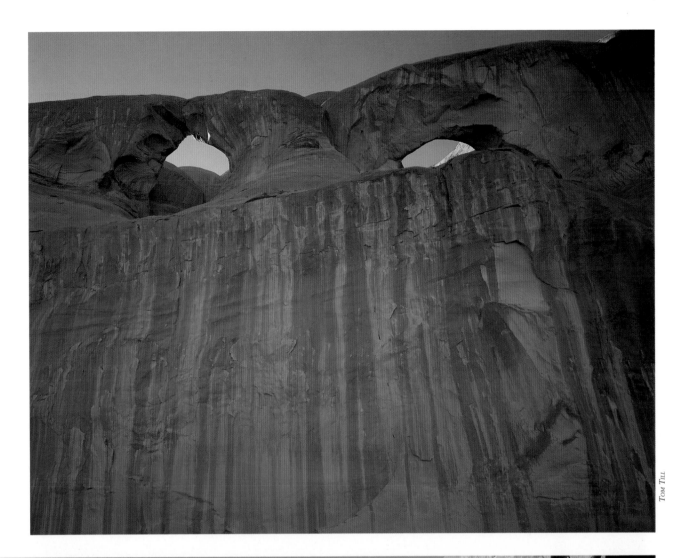

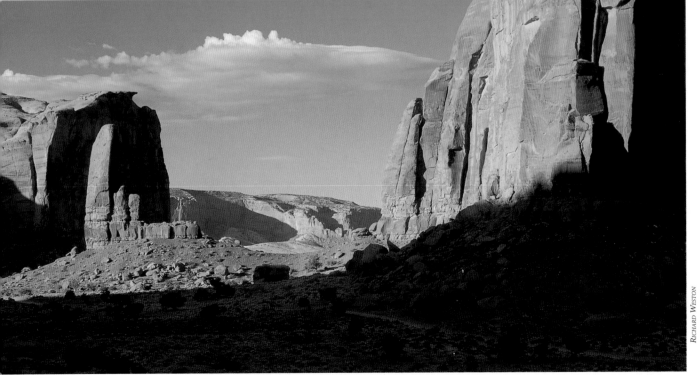

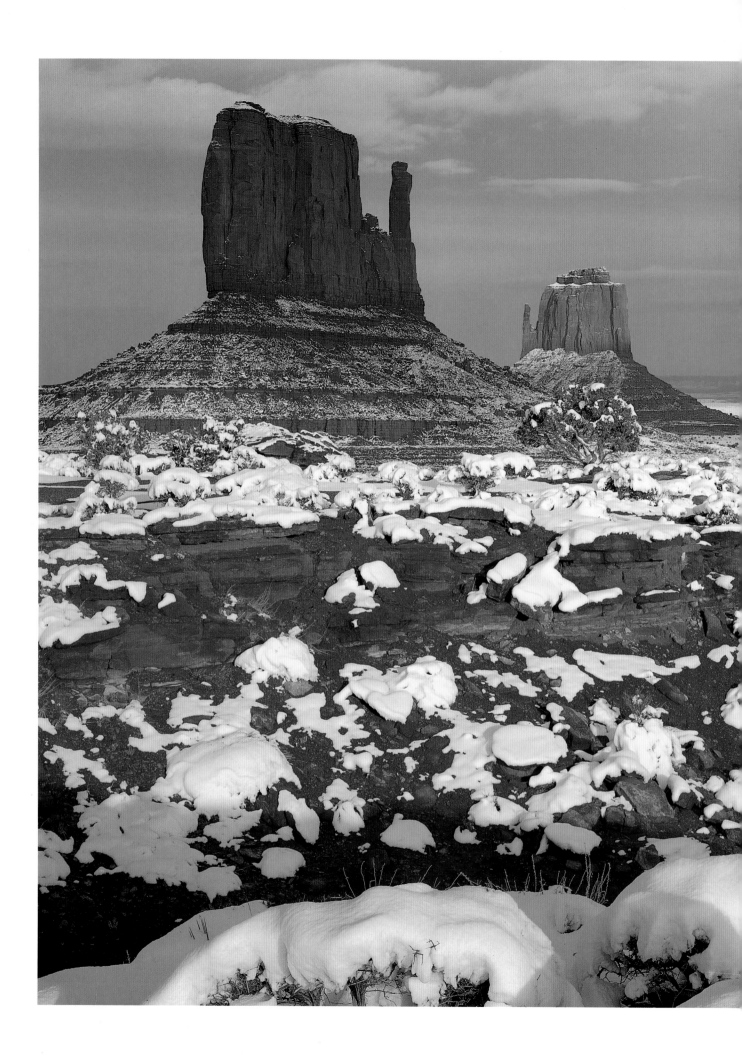

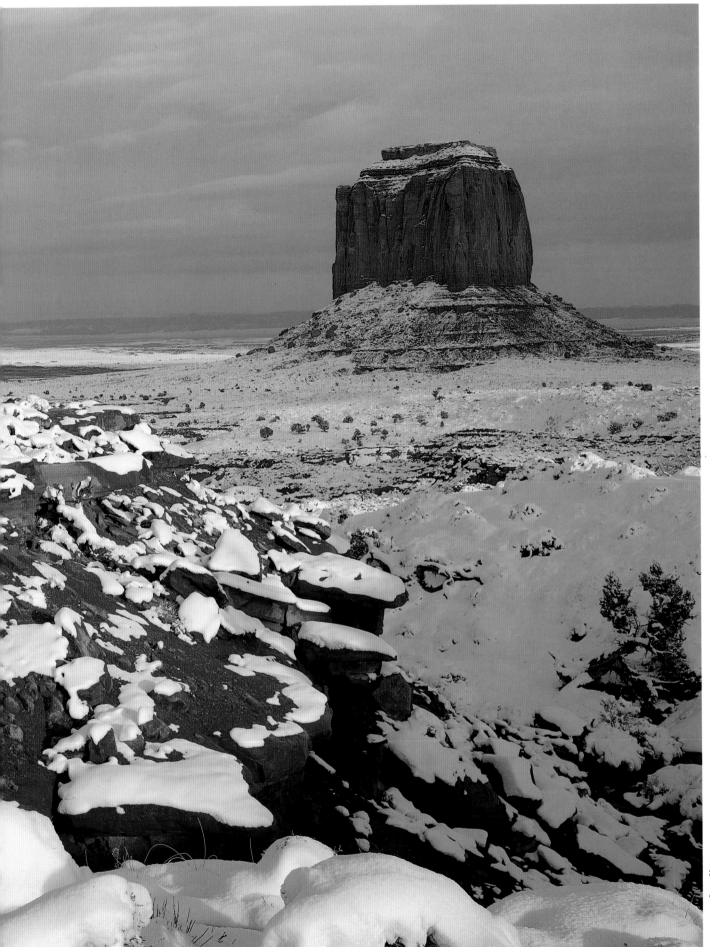

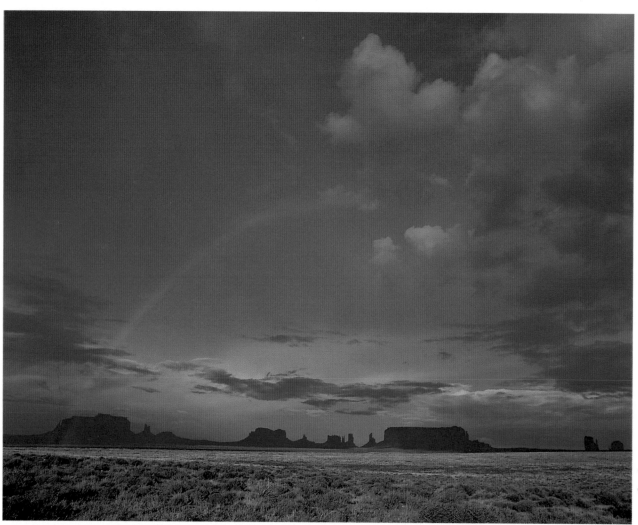

Nahasdzáán, nihimá
Yá diłhił, nihizhé'é,

Éé' adinįłdíinii nihá nitł'ó
Há'a'aah bishándíín łigaií bibąąh naat'i' le'
E'e'aah bishándíín łichíi'ii binanoolzhee' le'
Ni'dadizhoł bijánil le'
Índa naats'íílid bibąąhgóó aheenít'i' le'.

Nahasdzáán, nihimá
Yá diłhił, nihizhé'é!

Oh our Mother the Earth,
Oh our Father the Sky,

Weave for us a garment of brightness;
May the warp be the white light of morning,
May the weft be the red light of evening,
May the fringes be the falling rain,
May the border be the standing rainbow.

Oh our Mother the Earth,
Oh our Father the Sky!

—FROM THE SPIDER WOMAN LEGEND

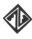

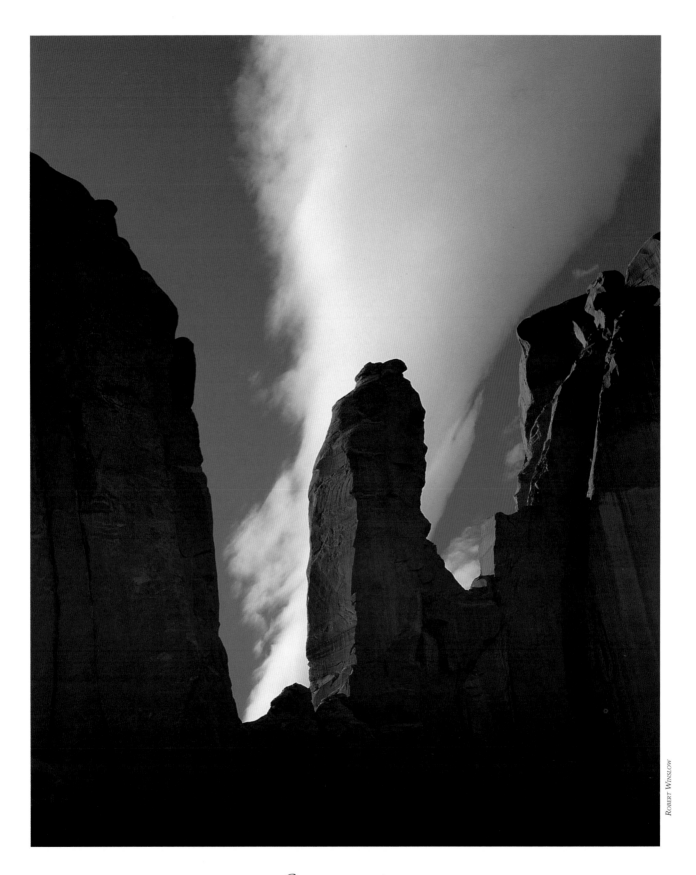

Cloud over Rain God Mesa.

Tom Till

Lightning outlines the distant mesas behind the Mitten Buttes.

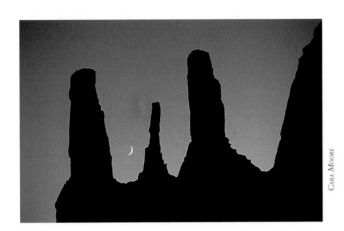

CARA MOORE

Moonset behind the Three Sisters.

Hayoolkááł bee hooghan
Ni'hootsoii bee hooghan
K'os diłhiłii bee hooghan
Níłtsábikạ' bee hooghan
Tózhool diłhiłii bee hooghan
Níłtsạ bi' ááд bee hooghan
Tádídíín bee hooghan
Nahachagii bee hooghan
K'os diłhiłii dáádilkałgi sizị́
K'os diłhiłii bii' ch'íhonít'i'
Atsiniltł'ish yikááh dasizị́
Hashch'ééłti'í
Nich'ị' naa'iishniih.

House made of dawn.
House made of evening light.
House made of the dark cloud.
House made of male rain.
House made of dark mist.
House made of female rain.
House made of pollen.
House made of grasshoppers.
Dark cloud is at the door.
The trail out of it is dark cloud.
The zigzag lightning stands high upon it.
Male deity!
Your offering I make.

—NAVAJO HOGAN SONG

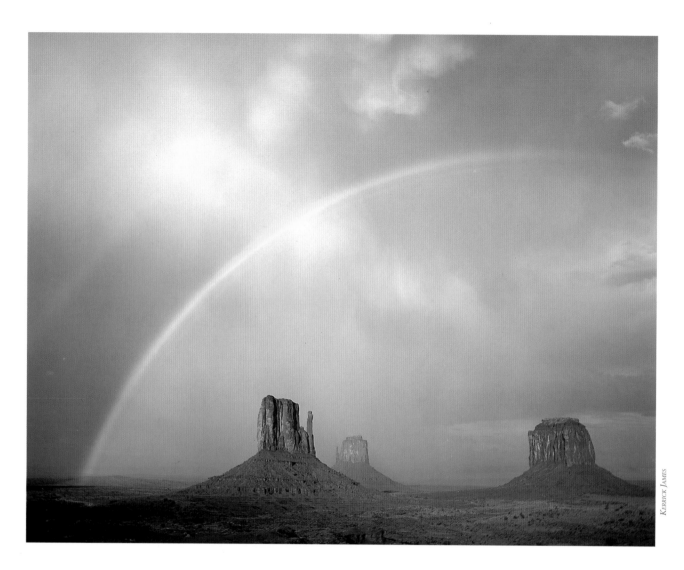

*Light, cloud, and rain create a
double rainbow over the Mittens and Merrick Butte.*

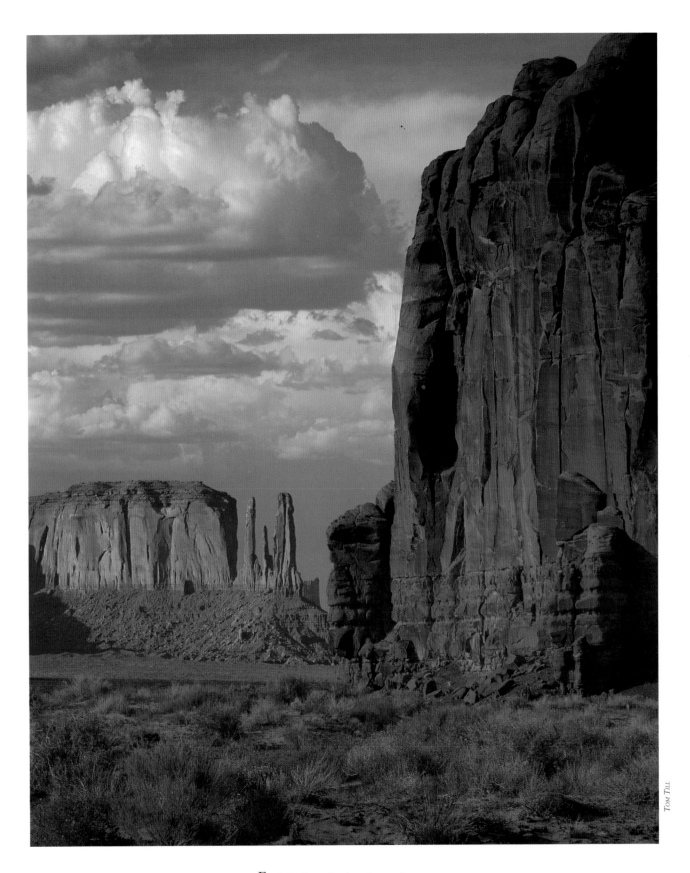

Tom Till

Eroded spires of rock at the southeastern edge of Mitchell Mesa are called the Three Sisters.

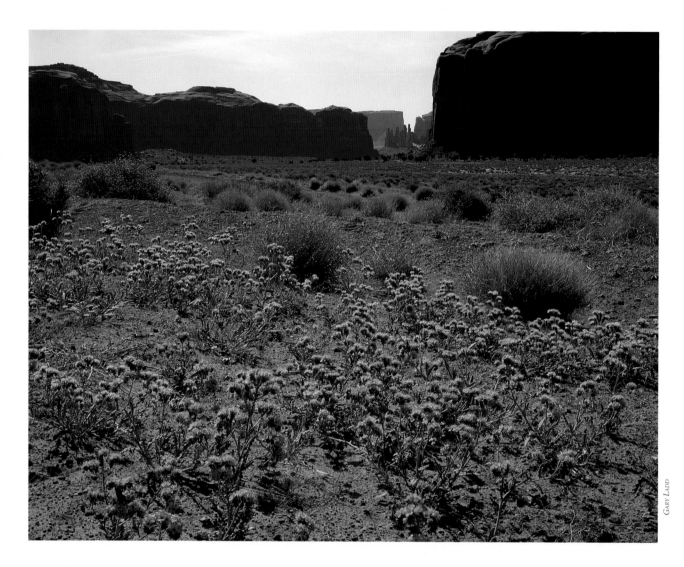

*Purple phacelia blooms emerge in spring from
the sandy soil near Rain God and Spearhead Mesas.*

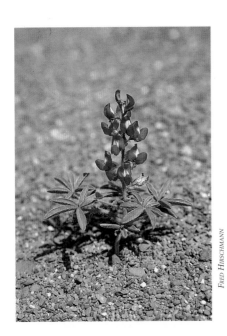

FRED HIRSCHMANN

Delicate lupine bursts from red sand.

. . . the strangeness and wonder of existence are emphasized here, in the desert, by the comparative sparsity of the flora and fauna; life not crowded upon life as in other places but scattered abroad in spareness and simplicity, with a generous gift of space for each herb and bush and tree, each stem of grass, so that the living organism stands out bold and brave and vivid against the lifeless sand and barren rock. The extreme clarity of the desert light is equaled by the extreme individuation of desert life forms. Love flowers best in openness and freedom.

–EDWARD ABBEY,
DESERT SOLITAIRE, *1968*

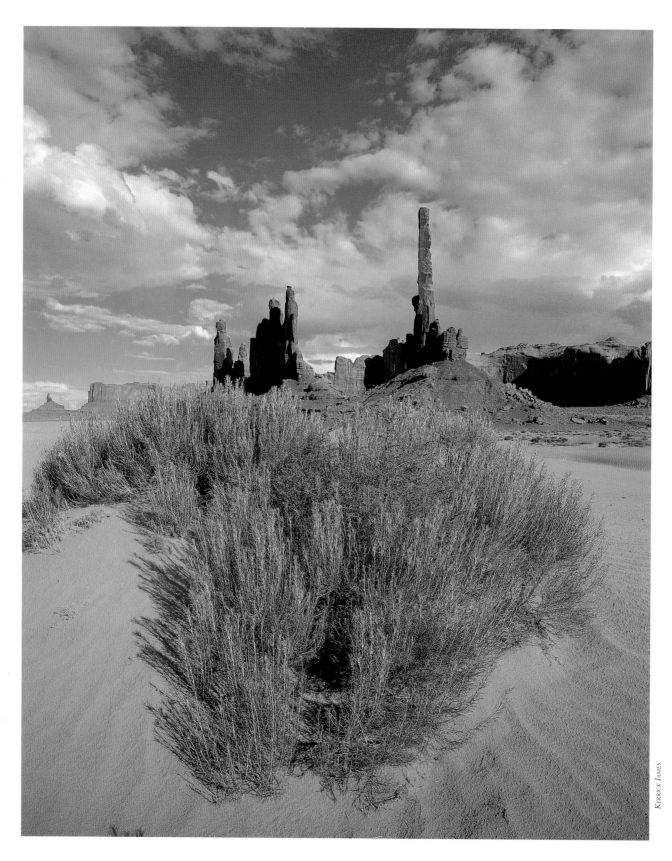

Vibrant greens splash the burnt red sands.

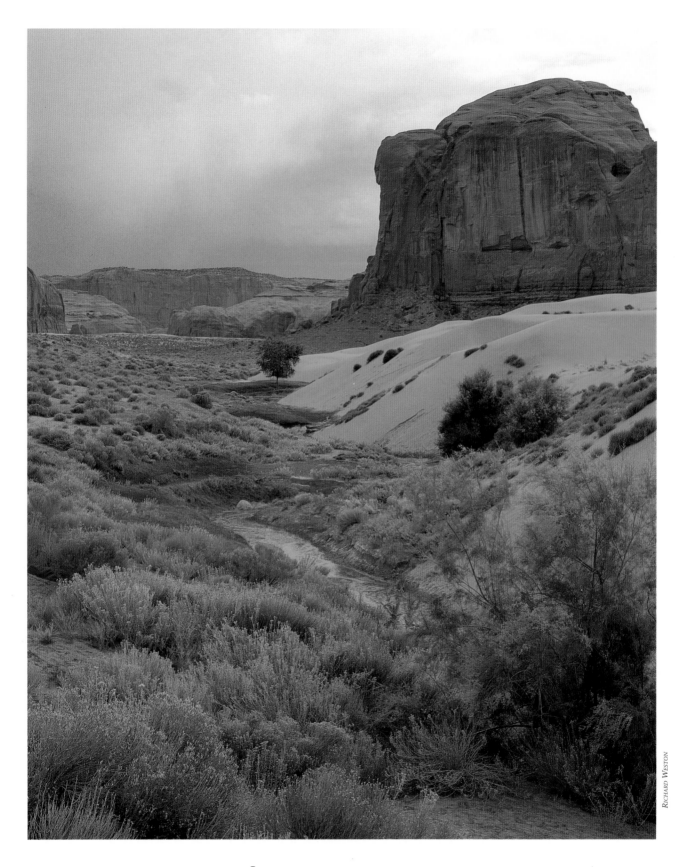

In the shadow of The Big Chair formation,
Gypsum Creek skirts the edge of sand dunes.

RICHARD WESTON

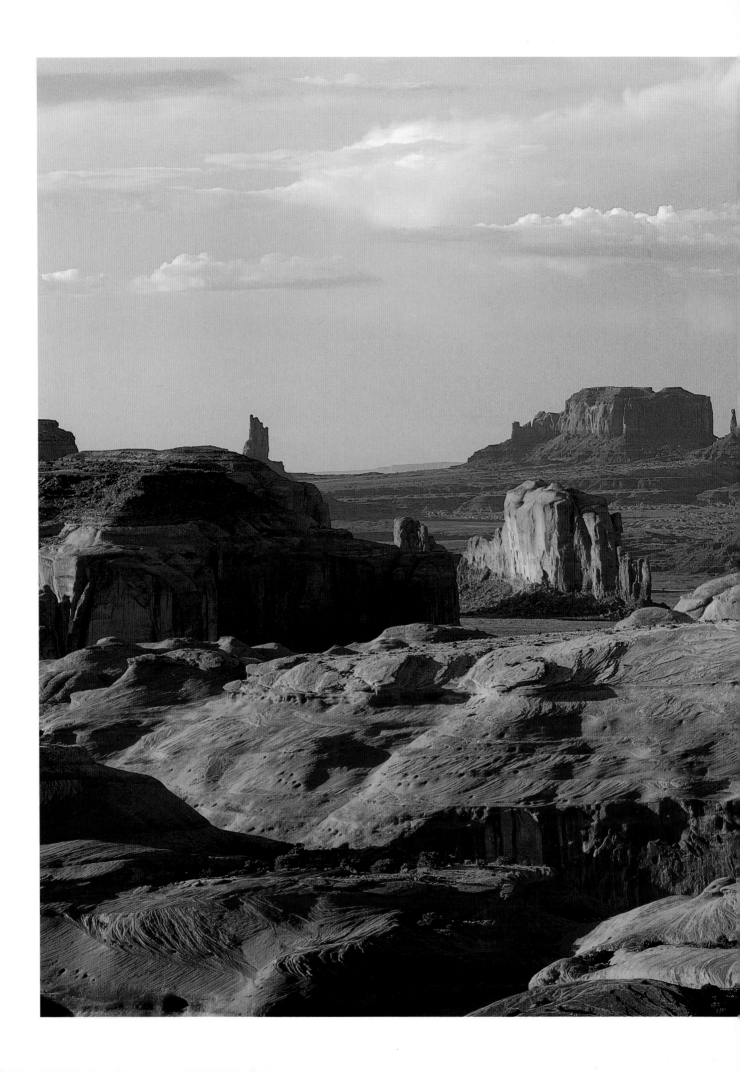

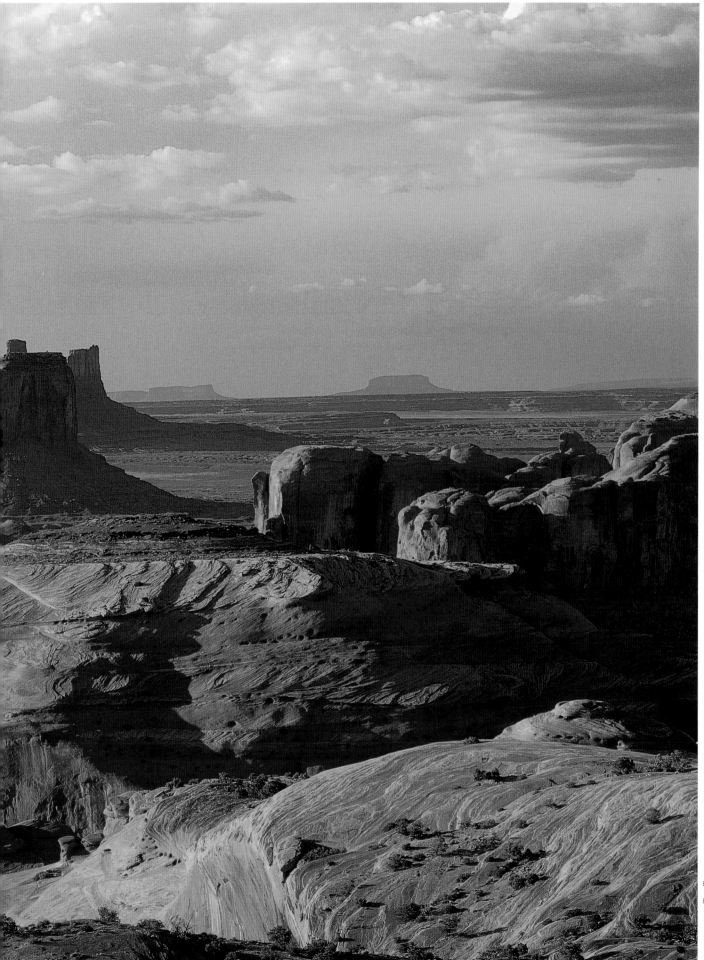

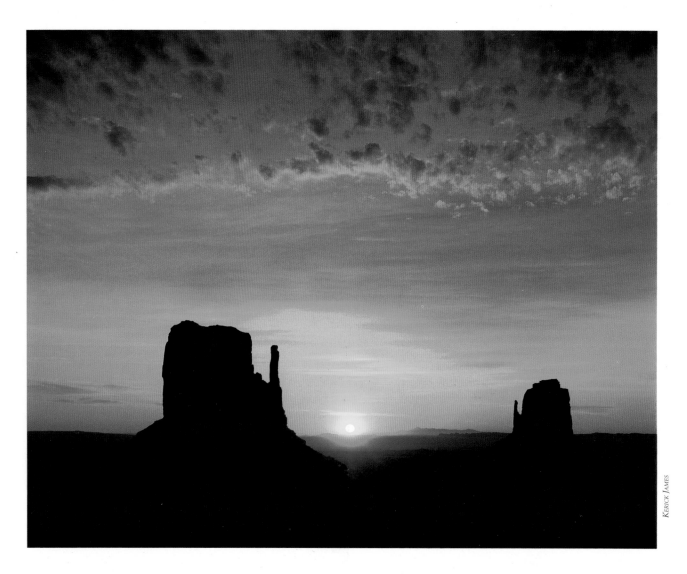

Kerick James

Hózhǫ́ǫgo naasháa doo	*In beauty I walk*
Shitsijį' hózhǫ́ǫgo naasháa doo	*With beauty before me I walk*
Shikéédęę' hózhǫ́ǫgo naasháa doo	*With beauty behind me I walk*
Shideigi hózhǫ́ǫgo naasháa doo	*With beauty above me I walk*
T'áá ałtso shinaagóó hózhǫ́ǫgo naasháa doo	*With beauty around me I walk*
Hózhǫ́ náhásdlį́į'	*It has become beauty again*
Hózhǫ́ náhásdlį́į'	*It has become beauty again*
Hózhǫ́ náhásdlį́į'	*It has become beauty again*
Hózhǫ́ náhásdlį́į'.	*It has become beauty again.*

*—Closing prayer from
the Blessing Way ceremony*

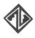